VAN EYCK TO GOSSAERT

TOWARDS A NORTHERN RENAISSANCE

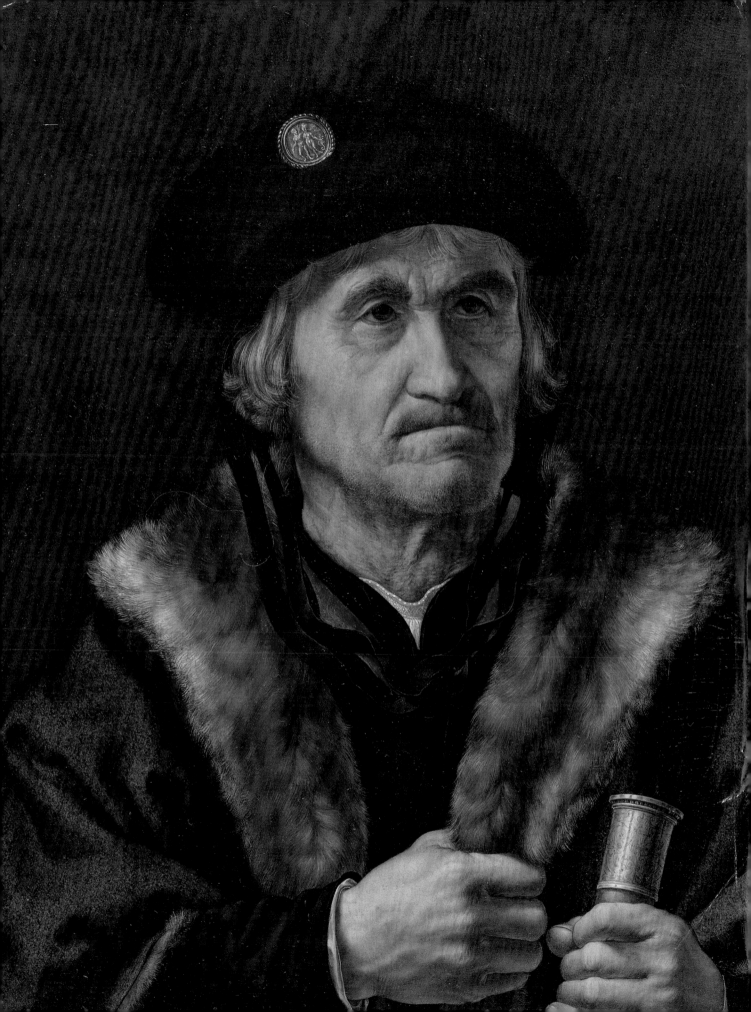

VAN EYCK TO GOSSAERT

TOWARDS A NORTHERN RENAISSANCE

SUSAN FRANCES JONES

NATIONAL GALLERY COMPANY, LONDON
DISTRIBUTED BY YALE UNIVERSITY PRESS

This book is published on the occasion of the exhibition
Jan Gossaert's Renaissance at the National Gallery, London
23 February – 30 May 2011

Supported by the Flemish Government

First published in Great Britain in 2011 by
National Gallery Company Limited
St Vincent House · 30 Orange Street
London WC2H 7HH
www.nationalgallery.co.uk

ISBN 978 1 85709 505 0 hardback 1018445
ISBN 978 1 85709 504 3 paperback 1018444

British Library Cataloguing-in-Publication Data
A catalogue record is available from the British Library

Library of Congress Control Number 2010937536

All measurements give height before width

All the works illustrated are from the National Gallery, London, unless otherwise indicated

PUBLISHING DIRECTOR Louise Rice
PUBLISHING MANAGER Sara Purdy
PROJECT EDITOR Giselle Sonnenschein
DESIGN Libanus Press, Marlborough
PICTURE RESEARCHER Suzanne Bosman
PRODUCTION Jane Hyne and Penny Le Tissier
Printed and bound in Spain by Grafos

Cover: Jan Gossaert (active 1503; died 1532), *The Adoration of the Kings*, 1510–15 (detail of plate 34)
Frontispiece: Jan Gossaert (active 1503; died 1532), *An Elderly Couple*, about 1520 (detail of plate 36)
Page 40: Rogier van der Weyden (about 1399–1464), *The Magdalen reading*, before 1438 (detail of plate 8)

CONTENTS

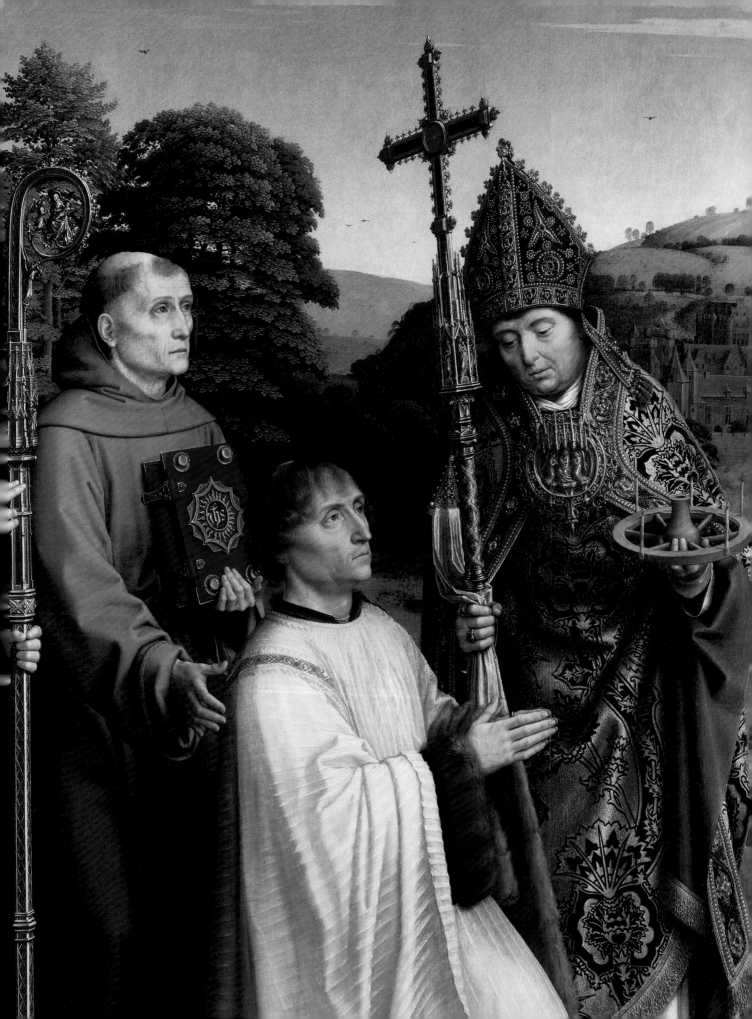

Netherlandish Painting from van Eyck to Gossaert

The appeal of Netherlandish panel paintings lies partly in their materials and techniques. From a distance, their rich, luminous colours attract our attention. Moving closer, we are astonished by their technical precision and attention to detail. They appeal to us partly because they seem to reproduce a world we can recognise, and do so with obvious skill. Nonetheless, Netherlandish painters aimed to do far more than imitate the things of this world. This book examines these paintings more closely in order to shed light on the ways in which they were seen and understood, used and valued in their own day.

During the timespan from about 1430 to about 1530 Netherlandish painting emerged as one of the most admired art forms in Europe. Its international success was shaped by such wide-ranging factors as the religious needs of the time, the desire for self-commemoration in portraiture and, crucially, the leading position of Netherlandish towns such as Bruges and Antwerp within a complex global network of trade and finance. In the fifteenth century and well into the sixteenth, the arts of the Netherlands set the style for the whole of Europe – not only in painting but also in such media as manuscript illumination and tapestry. New trends emerged in the early sixteenth century, however, as the art of classical antiquity and the artistic tradition of Italy grew in prestige.

FIG. 1
Gerard David (active 1484; died 1523)
Canon Bernardijn Salviati and Three Saints, after 1501
Detail of plate 21

In the fifteenth century the Netherlands were ruled by the dukes of Burgundy as part of the network of Burgundian territories comprising modern-day Belgium, the Netherlands, Luxembourg and areas of Northern and Eastern France. Their wealth was concentrated in the prosperous industrialised towns of Bruges and Ghent (in Flanders) and Brussels, Leuven and Antwerp (in Brabant). By 1400 the industrial focus of these towns had begun to shift from the production of quality cloth towards luxury goods, including paintings. Linked into a rapidly expanding international maritime trade network, the port towns of Bruges and Antwerp became the most important commercial and economic centres of Northern Europe. As European trade and exploration flourished – eventually extending as far as the coasts of West Africa, Asia and the Americas – these towns developed into thriving markets for the import and export of a vast array of raw materials, industrial products and luxury items, from spices to exotic woods, from glass to jewellery. At the same time they were gateways for the international export of Netherlandish arts.

The Burgundian court reached its apogee during the reign of Philip the Good (1419–1467), the third Valois duke of Burgundy. Philip derived great wealth from his prosperous Netherlandish towns, and the presence of his court was in turn a stimulus to their economic life. By the mid-fifteenth century the Burgundian court had become a model of princely magnificence and chivalry for the whole of Europe. After the death of Philip's son Charles the Bold (1433–1477), the last Valois duke of Burgundy, Charles's daughter Mary of Burgundy (1457–1482) married Maximilian I (1459–1519), Archduke of Austria and head of the House of Habsburg. The subsequent Burgundian–Habsburg dynasty was thus a direct continuation of the Burgundian line.

The most important figure in art patronage and collecting in the Netherlands in the early sixteenth century was Maximilian's daughter Margaret of Austria (1480–1530), who twice acted as Governor of the Netherlands (1507–15 and 1519–30).

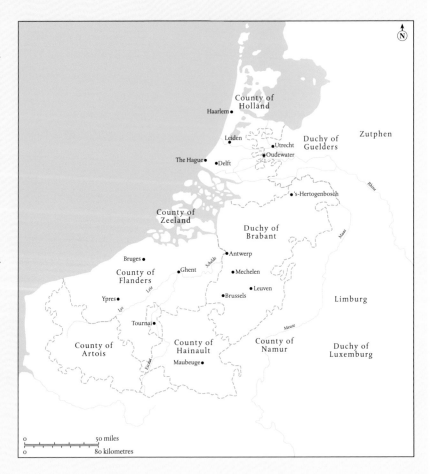

FIG. 2
The principal towns of the Burgundian Netherlands

THE TECHNIQUES OF NETHERLANDISH PAINTING

The use of an oil medium in painting is recorded as early as the twelfth century in Northern Europe, but it was the virtuoso handling of oil paint by Jan van Eyck, Rogier van der Weyden and their contemporaries that ensured its international success. By the sixteenth century oil had been adopted as the predominant paint medium in Europe – and later that century the painter and writer Giorgio Vasari (1511–1574) wrongly ascribed the invention of oil painting to van Eyck. Traditional techniques of South European panel painting had been based on egg tempera, in which the pigments were mixed in egg yolk. Since egg dries quickly and produces bright, light colours, it does not lend itself to reproducing naturalistic effects of texture or deep shadow. Thus when Federico da Montefeltro, Duke of Urbino, was looking for a court painter in the early 1470s, he considered skill in oil painting to be a central requirement. Unable to find a suitable artist in Italy, he enticed into his service Justus of Ghent, who painted the allegorical *Music* (plate 22).

The Netherlandish oil technique involved the application of paint in successive layers on a wooden panel, usually oak. An even surface was created by preparing the panel with a ground of chalk bound with animal glue. (Some Netherlandish pictures, including *An Elderly Couple* [plate 36] by Jan Gossaert, were painted on parchment, which produced a smooth working surface more quickly and could be attached to a panel afterwards.) Before the paint was applied, an oil-based priming layer was brushed broadly on to the ground, primarily to prevent the medium from sinking in to the absorbent chalk ground. It was standard practice for the painter or one of his work-shop assistants to execute a drawing on the panel as a guide to the painting. This 'underdrawing' was made either on top of the ground layer or the priming layer, usually in a quick-drying, aqueous medium with a brush but sometimes in other media: Hans Memling's *A Young Man at Prayer* (plate 18) was underdrawn in a dry medium, perhaps chalk (see fig. 3).

The properties of oil paint enabled Netherlandish artists to achieve remarkable fidelity to nature in their work. The fact that many pigments appear translucent when mixed in oil meant that they could be applied in thin layers or glazes, a technique used to create the brilliant, glowing reds and greens characteristic of Netherlandish painting and exemplified in van Eyck's famous *Arnolfini Portrait* (plate 3). This layering of

FIG. 3
Hans Memling
(active 1465; died 1494)
A Young Man at Prayer,
mid-1470s (plate 18),
infrared reflectogram
showing underdrawing
in a dry medium

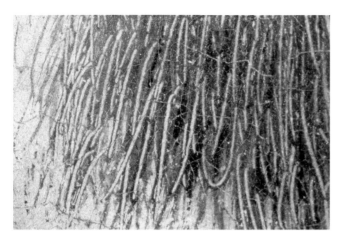

glazes also made it possible to create convincing effects of deep, translucent shadow. Oil was also uniquely versatile in that it could be applied in a range of thicknesses and, since it dried slowly, manipulated when still wet. This allowed the artist to make fine lines or thick strokes, produce smooth polished surfaces, scratch quickly with the end of the brush to create textural effects (see fig. 4) or scrape away a top layer of paint in a controlled fashion to expose the colour below (see fig. 5). With endless possibilities at their disposal, painters could make marvellously convincing facsimiles of the colours, textures and light effects of the real world.

A different aesthetic was produced by the other major painting medium of the Netherlands: glue-size painting, in which pictures were painted on cloth; because cloth is perishable, very few survive. This is a major impediment to our understanding of Netherlandish painting, since glue-size pictures were produced in large numbers and treated a wide range of secular as well as religious subjects.

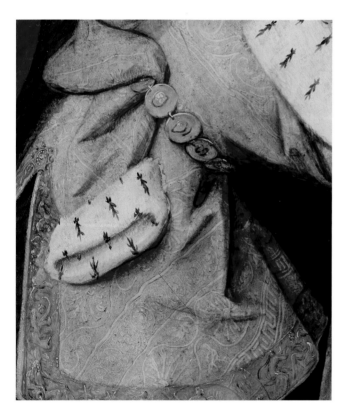

Glue-size was made by boiling animal skins and other tissues; this was then mixed with pigments and applied thinly to a linen cloth, itself prepared with a thin layer of glue-size. When mixed with glue most pigments appear matt and opaque rather than glossy and translucent, but their colours remain remarkably true to their raw selves: reds and blues can appear truly intense. Many glue-size paintings would originally have been brilliant in colour, but the few surviving examples show that the colours alter greatly over time. The degree of sophistication that could be achieved in glue-size technique is

FIG. 6
Dirk Bouts
(1400?–1475)
The Entombment,
probably 1450s
Detail of plate 12

demonstrated by Dirk Bouts, who was able to create both fine, linear detail and subtle tonal transitions (see *The Entombment,* plate 12, fig. 6). The effect of shadow could be created by the application of a thin layer of paint over the base colour, although alternative techniques were also employed: in *The Virgin and Child with Saints Barbara and Catherine* (plate 33), for example, Quinten Massys adopted a two-stage process to create the effect of deep shadow in the skirt of Saint Catherine's costume, at lower left. He painted an underlayer in a dark blue colour and then brushed on the vertical lines in a brighter blue, to represent lighter folds of material.

While it was possible to create effects of light and texture in glue-size, it was in oil paint that the language of Netherlandish art reached its fullest expressive potential. The medium made possible a material beauty, descriptive realism, minute detailing and dazzling illusionism, giving the figures a vivid sense of life and presence. The glowing translucency of the colours gives Netherlandish oil paintings a unique aesthetic appeal: in the hands of a master like van Eyck, red glazes can evoke the sumptuousness of such luxury techniques as enamelling over gold.

One of the most appealing characteristics of Netherlandish painting is its minute detailing. Even when painting a large-scale picture, such as *The Adoration of the Kings* (plate 34), Gossaert was at pains to display his marvellous ability to paint with clarity and precision on a small scale (see fig. 16). Thus we can experience the picture in different ways according to our distance from it: from far away, we are impressed by the bold spatial design and luminous colours; from close-to, we are amazed by the accuracy and complexity of the detailing.

The precision with which Netherlandish painters observed the natural world is apparent from their ability to make subtle distinctions between various types of reflected light, from a gentle gleam to a bright, shifting highlight (see figs 13 and 16). Sometimes we get a vivid sense of the close scrutiny that was brought to bear on individual objects, shown, for example, by the portrayal of traces of mud on a pair of pattens (outdoor shoes; see Jan van Eyck's *Arnolfini Portrait*, plate 3). *Saint Francis receiving the Stigmata* (fig. 7), from van Eyck's workshop, exemplifies the sense of reality evoked by Netherlandish landscapes. A convincing effect of deep space is created by imitating the effect of aerial perspective, objects appearing blue in colour, less detailed and smaller in scale the closer they are to the horizon. The rocks in the foreground are rendered with such accuracy that modern geologists have identified them as an outcrop of basalt on the left, and stratified layers of sandstone and shale on the right. Yet the scene is not a topographical view of Mount La Verna, where Saint Francis prayed, or indeed of any other locality. Such scenes are not objective records of real places but are imaginary, even if they rely partly on the study of nature.

Some of the figures depicted in Netherlandish art clearly rely on studies from life. Nevertheless, the new weight and tangibility of the figures in early fifteenth-century painting – including their stiff, angular draperies – probably derive in part from the observation of sculpture (see, for example, *The Virgin and Child before a Firescreen*, plate 6, from the workshop of Robert Campin and *The Virgin and Child in an Interior*, plate 7). The painter Gerard David, active in Bruges, was particularly interested in creating effects of sculptural presence, as shown by the strongly lit, blocky forms of the figures in his *Virgin and Child with Saints and Donor* (plate 20). Such effects also fascinated Jan Gossaert, who made drawings of a range of ancient sculptures while he was in Rome in 1508–9 (see fig. 20).

Representations of sculpture could also be used to play on the viewer's perceptions of reality. The closed view of the exterior of *The Donne Triptych* (plate 16) by Hans Memling presents the figures of saints as if they were stone sculptures, manipulating the boundary between real and pictorial space by

creating the illusion that the sculptures project out of their niches into the viewer's world.

Netherlandish painters extended their interest in illusionism to include *trompe l'œil* (eye deceiving) effects. These are particularly effective when we do not notice them immediately, but become aware of them only on closer examination. One of the torturers in *Christ Mocked* (plate 26) by Hieronymus Bosch wears a badge of oak leaves, represented actual size, whose stem seems to be threaded through the soft, nubby fabric of his hat while the crisp, seemingly tangible leaves appear to curl out into our space, breaking through the surface of the picture. This subtle device brings the entire figure of the torturer into vivid focus, forcing us to question our own relationship to the picture, and our own reactions and thoughts: as Christ gazes at us, awakening an uneasy sense that we are complicit

FIG. 7
Workshop of Jan van Eyck (active 1422; died 1441)
Saint Francis receiving the Stigmata, about 1440
Oil on panel,
29.2 × 33.4 cm
Galleria Sabauda, Turin

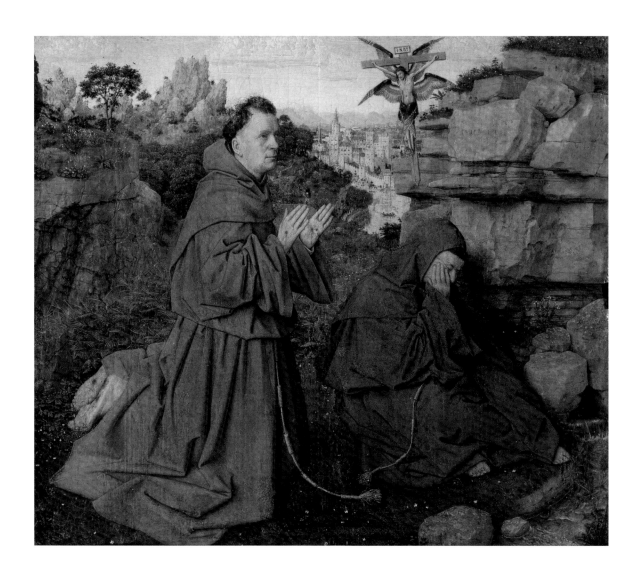

in his torture, we ask ourselves whether, or where, we fit into this circle of wicked human beings.

Awareness of the viewer's act of looking is a recurrent feature of these paintings. Like Bosch's Christ, figures sometimes stare out at the spectator, inviting reaction or implying participation (see, for example, Gerard David's *Christ nailed to the Cross*, plate 19, of about 1481). In van Eyck's *Arnolfini Portrait* (plate 3) the little dog, unlike its owners, stares directly out at us, while the convex mirror in the centre of the painting reflects the viewer's gaze back on itself. Interest in themes of seeing continued into the sixteenth century (see discussion of Pieter Bruegel the Elder's *The Adoration of the Kings*, plate 50, p. 138).

Netherlandish paintings were prized for their accurate portrayal of emotional states and capacity to arouse empathetic responses in the beholder. In Dirk Bouts's *Christ crowned with Thorns* (plate 14), each tear of the weeping Christ is rendered with crystalline clarity. The expressive power of abstract lines and shapes was also exploited as a means of awakening a response in the viewer, an approach explored with great success by one of the leading painters of the period, Rogier van der Weyden. In his *Magdalen reading* (plate 8), the figure is compressed into a semicircular shape that perfectly expresses her internal absorption. The abstract linearity of Rogier's designs gave them a unique dramatic intensity.

FUNCTIONS OF NETHERLANDISH PAINTING

Devotional Pictures

The rapid escalation of private prayer and devotion in the fourteenth and fifteenth centuries is one of the major developments of the period. This allowed both members of the Church hierarchy and the laity to personalise their religious experience in various ways, such as by choosing individually significant prayers and images. Paintings and other objects – such as prayer beads or books of hours containing prayers for different times of the day – created a visual environment for personal prayer and meditation. These objects were an important aid to devotion that aimed to obtain the protection of the saints and ensure the soul's salvation. *The Magdalen in a Landscape* (plate 44) attributed to Adriaen Ysenbrandt depicts Mary Magdalene in solitary prayer, with accessories of private devotion: a book of hours and an image, in this case a carved and polychromed Crucifix.

Paintings of Christ and the saints were believed to enable the user to perceive God not with corporeal sight associated with the physical world, but with spiritual sight – the eyes of the mind. Meditation on a painting could transport the

devotee to a higher level of seeing. Dirk Bouts's *Virgin and Child* (plate 13) was probably used for private prayer: it is fairly small in scale, and thus suitable for individual viewing; the holy figures are represented in an intimate domestic space, closed off by a cloth hanging – the sort of environment in which such a picture may have been used. Here Bouts exploits the illusionism of oil painting to overcome the limitations of the two-dimensional picture plane. The figures appear as if at a window, in a clearly defined and convincing space, and some of their possessions – the infant's cushion and the cloth beneath him – seem to project into our space, making them appear close and accessible. These effects are particularly appropriate for private worship, in which the intimacy of the painting and the feelings it generated were the basis for devotional exercises that aimed to transport the user beyond the material world.

A particular form of private devotion was to participate in the events of Christ's life by reconstructing them mentally, in the mind's eye. This meditative practice was supported by literary texts which provided detailed, moment-by-moment accounts of the Nativity and Passion: important examples are the thirteenth-century *Meditations on the Life of Christ* by an anonymous, probably Franciscan, writer, and the fourteenth-century *Vita Christi* (*Life of Christ*) by the Carthusian Ludolph of Saxony. The reader visualised the events described in the text, imagining him- or herself to be present and entering into the drama imaginatively by, for example, inventing dialogue, touching Christ or asking a question of the Virgin; above all, the reader aimed to cultivate profound feelings of compassion for Christ in his sufferings. In order to help people achieve these difficult goals of intense personal empathy, devotional pictures often show moments of acute suffering or sorrow, such as Bouts's *Christ crowned with Thorns* (plate 14) or David's *Christ nailed to the Cross* (plate 19). Some include convincing portrait-like images of saints or holy figures with whom the viewer might identify: the figure of Saint Francis at prayer in *Saint Francis receiving the Stigmata* (fig. 7) from van Eyck's workshop serves this purpose, as well as being a devotional model for the user to emulate.

A similar role was no doubt played by the figure of the Virgin Mary, shown at her devotions in a palace-like setting, in the little painting made by Juan de Flandes for Queen Isabella of Castile (plate 27), but here the devotional experience is further shaped by dialogue. The text of a scroll in Isabella of Castile's painting, derived from the *Meditations on the Life of Christ*, enabled the Queen to imagine Christ speaking its joyful words: 'My sweetest mother, it is I. I have risen and still am with you …' While the words are present in the picture itself, elsewhere prayers might be positioned alongside images, as demonstrated by a triptych in the Gallery (the *Virgin and Child* triptych of about 1485, plate 23). *Portrait of a*

Young Man (plate 11) by Petrus Christus includes a prayer dedicated to the *veronica*, a revered icon, on the wall above the sitter's head.

A popular format for devotional images was the diptych, consisting of two panels, often hinged together, that could be closed like a book. It was a distinctly Netherlandish practice to devote one of the interior paintings to a full-length or half-length portrait of the patron in prayer: the half-length version was a type probably invented, but perhaps only revived, in the 1450s by Rogier van der Weyden, who made several such objects for members of the Burgundian court. Most of these portrait diptychs depict male patrons (see plates 11, 18, 25 and 39). Objects of devotion and prestige, they were often portable and could thus be taken from private spaces into the public sphere. Like the exteriors of the wings of small triptychs (such as Memling's triptych for Benedetto Pagagnotti, plate 17), one exterior panel might be given over to an elegant display of heraldry, calligraphy or nuanced grisaille work (painted in grey tones). By the early sixteenth century both exterior panels might be decorated, sometimes giving the appearance of an object constructed from a variety of rare stones and marbles. The best of these objects were the epitome of courtly refinement.

Diptychs can only be understood fully by observing the relationship between their interior and exterior views. The interior of a diptych made by Jan Provoost for a Franciscan friar shows *Christ carrying the Cross* on the left panel and the owner of the diptych on the right, both figures in extreme close-up to ensure an intimate devotional experience (fig. 8). The reverse of the panel showing the patron is decorated with a *memento mori* (reminder of death) in the form of a skull in a stone niche; the reverse of the other panel, on the other hand, is decorated in imitation red-and-white marble, combining cloudy areas of red paint with sharp splashes of white (fig. 9). Such illusionistic renderings of stone are often simply decorative; in this case, however, the position of the marbled panel, with its strange patterning, suggests that it gained meaning from its physical connection with Christ's Passion.

Altarpieces

Altarpieces were made in various formats and materials: that depicted in Rogier van der Weyden's *Exhumation of Saint Hubert* (plate 9), for example, may be an embroidered textile. The main function of altarpieces was to serve as a locus for the Catholic Mass, the liturgical re-enactment of Christ's sacrifice of his body and blood using consecrated bread and wine. As such they often display the body of Christ in subjects such as the Crucifixion or the Deposition from the Cross. Alternatively, they may depict the holy figure or saint to whom the altar

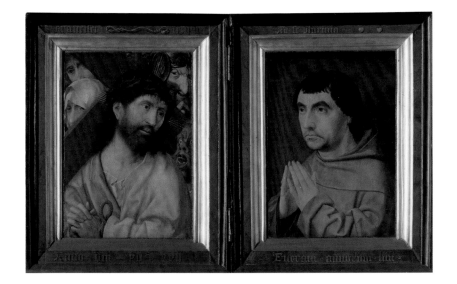

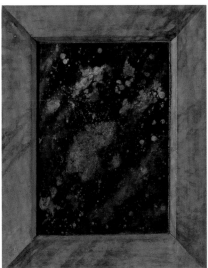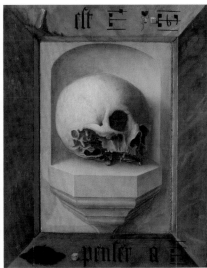

was dedicated: Gossaert's *Adoration of the Kings* (plate 34), for example, was probably installed in the Lady Chapel of the abbey church of St Adrian in Geraardsbergen (Grammont), near Brussels. As shown by this altarpiece, and an earlier example by Ghent artist Hugo van der Goes (fig. 10), the subject of the Adoration of the Kings, displayed in a formal and relatively public setting, encouraged painters to demonstrate the range of their skills, including the grouping of figures in a deep architectural space and the meticulous rendering of a variety of textures and materials, from exotic fur to cloth-of-gold.

A painted panel showing the donor Bernardijn Salviati and three saints is the left-hand wing of a large-scale diptych by Gerard David that originally

FIG. 10
Hugo van der Goes
(active 1467; died 1482)
*The Monforte
Altarpiece,*
about 1470
Oil on panel,
150 × 247 cm
Gemäldegalerie,
Staatliche Museen
zu Berlin

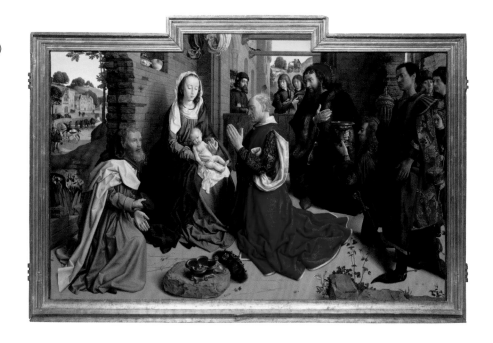

functioned as an altarpiece (plate 21). The reverse of this panel, visible when the diptych was closed, shows a coloured image of the resurrected Christ at a *trompe l'œil* window set in a monochrome wall. The shutters of the window hint at the opening and closing mechanism of the diptych while the image of Christ offers a separate focus for prayer and devotion.

The diptych was a relatively rare format for an altarpiece, but the winged triptych was a common choice. An example is the altarpiece of the *Passion of Christ* by the Master of Delft (plate 28), in which the two side panels are hinged to form a pair of wings that can be closed over the wider main section. Probably installed on the high altar of the church of the convent of Konigsveld, near Delft, the altarpiece served as a setting for the High Mass. Its whole structure is defined by the contrasting imagery of the panels: the exterior is decorated with images of holy figures in the form of stone statues in niches, while the focus of the interior is the central scene of the Crucifixion in brilliant colour, flanked by scenes from the Passion. This sets up a contrast between different levels of reality, the body of Christ in the interior seemingly more 'real' than the fictive stone figures on the exterior. Taken as a whole, the ensemble transports the viewer from the large-scale, iconic monochrome figures depicted on the exterior to the small-scale, densely packed narratives and glowing reds and greens of the interior, with Christ crucified, raised on high in the centre, as the visual climax.

The Haywain Triptych, *attributed to Hieronymus Bosch*

Hieronymus Bosch's approach to the structure of triptychs was innovative. The interior view of the *Haywain Triptych* features a wagon piled with hay and surrounded by crowds of grasping, violent people, an allegorical representation of man's avarice and lust. This was a new type of subject matter for the interior of a triptych, offering not divine revelation but a strong dose of moral self-reflection focused on man's worldly behaviour. The triptych sets man's immorality within a cosmic framework: on the left inner wing is the Fall of Adam and Eve, which brought evil into the world, and on the right, the punishments of hell. On the exterior, Bosch overrides the traditional scheme of decoration for the winged triptych by positioning the central figure directly over the physical division between the wings. This man, a peddler, is presented as a repentant sinner. To open the triptych, the user must 'divide' his body, moving from the individual sinner to the sins of all mankind. It is unlikely that this painting was an altarpiece: its worldly and complex, even erudite themes suggest that it was kept for private contemplation by a wealthy patron.

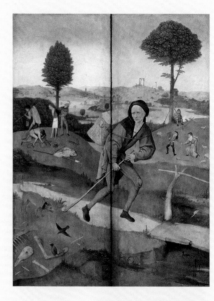

FIG. 11
Attributed to Hieronymus Bosch (living 1474; died 1516) *Haywain Triptych*, about 1500–5, closed view: *The Peddler*
Oil on panel, 135 × 90 cm
Museo Nacional del Prado, Madrid (2052)

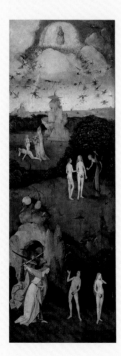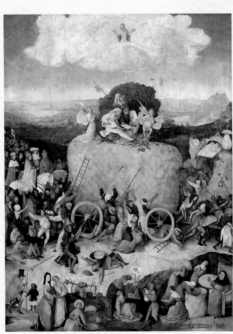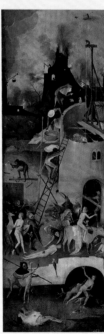

FIG. 12
Attributed to Hieronymus Bosch (living 1474; died 1516) *Haywain Triptych*, about 1500–5, open view: *Paradise, The Haywain (Earth)* and *Hell*
Oil on panel, 135 × 190 cm
Museo Nacional del Prado, Madrid (2052)

Portraits

The flexibility of oil painting made it inherently suited to capturing likeness. In his portrait *A Man aged 38* (plate 42) Lucas van Leyden exploits the capacity of oil paint to record the smallest and most delicate fluctuations in tone and colour moving across the sitter's face. The reflections of a window in his eyes suggest that he is looking into bright daylight. In its intense scrutiny and accurate rendering of the particularities of the man's face it is typical of Netherlandish portraits. Whereas Italian portrait painting favoured the profile view for much of the fifteenth century, Netherlandish painters presented the sitter in three-quarter view, showing more of the face and allowing for a sense of communication with the viewer.

Netherlandish portraits sometimes allude to the inner life and character of the sitters. Robert Campin's portraits of *A Man* and *A Woman* (plates 4 and 5) present the couple as a contrasting pair. The woman appears upbeat, her eyes and veil making distinct upward curves, whereas the man appears grave and restrained; her eyes are enlivened by brilliant highlights, while his are dim and muted. In his double portrait of *An Elderly Couple* (plate 36), painted in the early sixteenth century, Jan Gossaert brings out a range of evocative and subtle contrasts between the sitters. By misaligning the gazes of his sitters the artist also suggests that, though bound together in life, each has private thoughts and feelings. The man's cap badge is decorated with an image of a naked couple with a cornucopia (a symbol of fruitfulness and plenty), emphasising the mature years of his subjects and the passage of time. Characteristically, Gossaert explores this theme in minute detail, flawlessly capturing the textures assumed by ageing skin, varying skin tones and even depicting individual hairs that have fallen from the man's head. Such allusions to the fragility of life are common in Netherlandish portraiture of this period: in van Eyck's *Portrait of a Man ('Léal Souvenir')* (plate 1), for example, the crumbling and cracked stone parapet seems to hint at man's mortality.

Portraits often placed the sitter within a broader world of symbolism and allusion. Poses, gestures, settings, costumes and accessories could be used to communicate social status and wealth (see the *Arnolfini Portrait*, plate 3, or Gossaert's *Man holding a Glove*, plate 35), though they could also imply more subtle personal qualities such as wisdom, piety or modesty. A small-scale portrait of a lady (plate 49) by Catharina van Hemessen personalises the sitter by including her fragile-looking dog.

Few Netherlandish painters signed their work. An exception was Jan van Eyck, who is conspicuous for the inventiveness and variety with which he identified himself. Fascinated by lettering design and by the relationships between tools, materials and letter forms, he regularly signed his name in fictively crafted letters: they may appear, among other things, to be carved into stone, engraved into metal or embossed. In *Portrait of a Man (Self Portrait?)* (plate 2) the painter's personal motto and his signature appear on the frame. Since the motto '*Als ich can*' (As I can) is inscribed on the upper frame, the word '*ich*' directly over the sitter's head, this painting is probably a self portrait. The frame is gilded with real gold, and the inscriptions imitate letters carved in wood and then gilded. Van Eyck so successfully closes the gap between the materiality of the gold and the illusionism of the paint that he deceives us into thinking that the letters are actually carved. At the moment of recognition we marvel at the artist's skill. In antiquity the painter's skill at faithfully representing objects observed in nature was celebrated, as when the ancient Greek painter Zeuxis painted grapes so realistically that birds tried to peck at them. Van Eyck's *trompe l'œil* device does not create the illusion of something that he had seen in front of him, however, but rather of an effect of art, something he has imagined. His self portrait as a whole – including the frame – advertises a range of his skills and insists, above all, that they are unique to him.

In his *Arnolfini Portrait* (plate 3) van Eyck asserts his presence by inscribing the words '*Johannes de eyck fuit hic*' (Jan van Eyck was here) in the centre of the picture, and by representing himself in the reflection in the mirror below (see fig. 13). The mirror shows the couple standing in the room but this time from the rear, and includes things the viewer cannot see in the painting, including the image of van Eyck himself, with a companion, about to enter the room. Following the logic of the reflection, van Eyck is standing in the space in front of the picture, where the viewer now stands. Identified with van Eyck, we too are invited to 'enter' the chamber. Through this device, van Eyck encourages us to participate actively in the world of the image.

In keeping with van Eyck's interest in signatures and self portraits, his personal identity was relevant to the value of his paintings. A document of payment of 1444 for a now-lost painting of *Saint George and the Dragon*, which had just been purchased for King Alfonso V of Aragon, describes it as being 'by the hand of Master Johannes, the great painter of the illustrious duke of Burgundy'. This emphasis on van Eyck's authorship is remarkable for the period, when painters often remained anonymous.

FIG. 13
Jan van Eyck (active
1422; died 1441)
The Arnolfini Portrait,
1434, detail showing
mirror and signature
Detail of plate 3

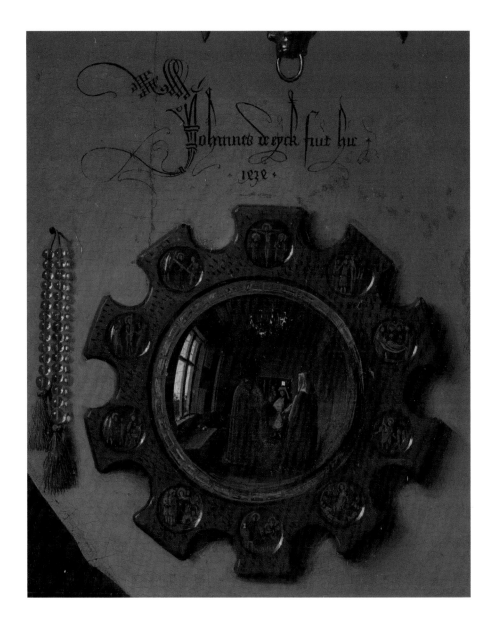

Aside from his signatures, van Eyck designed other playful and intellectually intriguing devices. In his motto '*Als ich can*', written in his native dialect of Limburg Dutch, he replaces some of the letters with Greek ones that sound broadly similar. The motto's play on 'Ich/Eyck' also relies on the fact that the words sound alike. Van Eyck employed Greek letters again in his *Portrait of a Man* inscribed '*Léal Souvenir*' (plate 1) in which, at the top of the parapet, is inscribed the short, enigmatic inscription ' ΤΥΜ· ωθΕΟΙ '. A comparable device by another painter, in that it requires decoding, is the pictogram, shown in the diptych by Jan Provoost (figs 8 and 9, p. 17): on the reverse, painted on the frame above and below the skull, a series of images, words and musical notations can be deciphered to read

(in French): 'Hard is the thought of death; it is good to think on death' (see fig. 9). The imagery was intended to turn the user's mind to the transience of life, to encourage him to ponder the decay of the body and the eternality of the soul.

Few Netherlandish painters were able to rise to the challenges posed by van Eyck, but Jan Gossaert was an exception. Like van Eyck, he had a relatively secure salaried position at court, which granted him a certain degree of artistic freedom. In *Danaë* (fig. 14) Gossaert emulates van Eyck by painting his signature in letters that imitate stone-carving. *A Young Princess* (plate 38; probably Dorothea of Denmark) contains an anagram, perhaps his signature, on one of the rings of the armillary sphere held by the girl. In *The Virgin and Child* (plate 40) Gossaert accomplishes the intentionally difficult feat of painting convex metal letters affixed to a concave stone moulding, all lit from the left and casting distorted shadows. This may be compared with the virtuoso stone carving in the church of the monastery of St Nicholas of Tolentino at Brou, the burial place of Margaret

FIG. 14
Jan Gossaert (active
1503; died 1532)
Danaë, 1527
Oil on panel,
113.5 × 95 cm
Alte Pinakothek,
Bayerische
Staatsgemälde-
sammlungen,
Munich

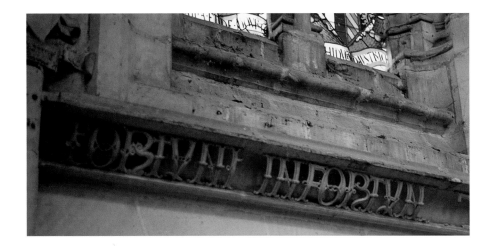

FIG. 15
Motto of Margaret
of Austria ('*Fortune
Infortune Fort Une*'),
stone carving, choir
of the church of the
monastery of
St Nicholas of
Tolentino, Brou

FIG. 16
Jan Gossaert (active
1503; died 1532)
*The Adoration of the
Kings*, 1510–15
Detail of plate 34

of Austria, which spells out Margaret's motto ('*Fortune Infortune Fort Une*') in convex letters (fig. 15). Such virtuosity in carving was highly prized at this period, and Gossaert himself seems to have been valued as a designer of a particular form of highly intricate architectural ornament (see p. 106). His interest in inscriptions and ornamentation reminds us that, like other painters of his day, he was active as a designer of works in other media. Among other things, he designed a triumphal chariot for the 1516 funeral procession of King Ferdinand of Aragon, adorned with explanatory inscriptions in large gold letters.

Gossaert is also said to have used *trompe l'œil* trickery. According to an account by the Netherlandish painter and writer Karel van Mander, published in 1604, Gossaert deceived the Holy Roman Emperor Charles V into believing that a robe he wore for the Emperor's visit, which he had made with paint and paper, was made from white silk damask: 'And when the Marquis, as they passed by asked the Emperor which damask he thought the most beautiful the Emperor had his eye on that of the painter, which – being very white and beautifully decorated with flowers – far excelled all the others.' So complete was the illusion that the Emperor is said to have realised his mistake only when he felt the 'damask'. Even if this strange tale is apocryphal, it elevates Gossaert to the level of painters whose remarkable skill was put to playful use, honouring him by suggesting that his powers of deception were appreciated by the most powerful ruler of the period. His skill in designing beautiful textiles can be seen in *The Adoration of the Kings* (plate 34 and fig. 16).

PATRONS AND BUYERS

From 1425 until his death in 1441 Jan van Eyck was court painter to Philip the Good, the third Valois duke of Burgundy. Unfortunately none of his paintings known to have been made for the duke survives, although it is recorded that, as part of an embassy to Portugal, he made Philip a portrait of his prospective bride, Isabella of Portugal. It is likely that a small-scale devotional triptych by van Eyck, one wing of which shows the *Annunciation* (National Gallery of Art, Washington, DC), was painted for the duke or duchess.

The taste of the dukes of Burgundy is more usually associated with such luxury media as intricate goldsmith work, mounted jewels, enamelled gold and tapestries woven with gold threads. The Court Cup of Philip the Good (fig. 17), for example, is a *tour de force* of carving in the highly prized material of crystal. The cup would have been valued for its finely balanced combination of two rare and contrasting materials, of simple shapes and intricacy, translucency and opacity. Panel painting, of course, had none of the inherent value of such media: gold, if used at all, was only a veneer. Yet although painting could not equal gold, jewels or tapestry for the value of their materials, Philip must have admired the medium for its own unique properties. His esteem for van Eyck as a painter is clear: a document of 1425 tells us that he employed van Eyck *'pour cause de l'excellent ouvrage de son mestier qu'il fait'* (because of the excellent work

FIG. 17
The Court Cup of
Philip the Good,
Burgundian
Netherlands, 1453–67
Rock crystal and gold
with pearls,
diamonds and rubies,
height 46 cm
Kunsthistorisches
Museum, Vienna
(KK 27)

that he does in his craft). In a letter of 1435 to his accountants in Lille, Philip fulminates at their delay in verifying letters patent granting a life pension to van Eyck, who was threatening to leave his service. This would bring him very great displeasure, he warns, 'for we would retain him for certain great works with which we intend henceforth to occupy him, and we would never find another painter so much to our taste nor so excellent in his art and science'. Philip ends the letter with the instruction that the accountants resolve the issue at once, 'without further talk or argument, delay, alteration, variation or difficulty whatever'. The peremptory tone of this dressing down is testimony to the level of the duke's regard for van Eyck and his skill as a painter.

The prestige of Netherlandish painting led foreign princes and royalty to seek out Netherlandish painters, or artists trained in the tradition, to work

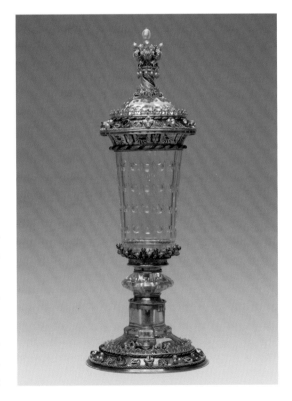

at their courts. We have already noted that Federico da Montefeltro, Duke of Urbino, employed Justus of Ghent as one of his court painters (see p. 9). In Spain, Queen Isabella of Castile employed from 1496 Juan de Flandes, a Netherlandish painter whose place of training is unknown. In collaboration with another of Isabella's painters, Michel Sittow (1468/9–1525/6) from Tallinn in Estonia but trained in the Netherlands, Juan de Flandes painted a series of no fewer than 47 small devotional paintings for Isabella.

By the 1510s the artistic tradition of Italy was rapidly establishing itself as an international model. The courtly milieu of the Habsburgs and the nobles in their service was central to the diffusion of Italianate classicism in the Netherlands. An important figure in Northern Europe was the Venetian artist Jacopo de' Barbari (active 1500; died 1516?), who, having knowledge of theories of human proportion, among other things, attracted great interest among patrons and artists; he worked at various German courts before being employed from 1510 by Margaret of Austria at her court in Mechelen, near Brussels. The majority of the classicising pictures in Margaret's collection, referred to in her inventories as 'à la mode d'Italie' or 'à l'antique', were nonetheless painted by Netherlandish and Northern European artists. In addition, she prized the paintings of Juan de Flandes and Michel Sittow, both of whom worked in the established Netherlandish tradition, and those of Hieronymus Bosch, whose novel and idiosyncratic imagery enjoyed great success at the highest levels of Habsburg society. This pluralism of taste was a distinctive feature of early sixteenth-century Netherlandish patronage and collecting. It is also manifested in Margaret's high esteem for the art of the fifteenth-century Burgundian Netherlands, which reflected her personal taste but was strengthened by her direct descent from the Burgundian dukes. Her inventories reveal that she owned pictures by an array of fifteenth-century masters, including Jan van Eyck, Rogier van der Weyden and Hans Memling. Among her paintings by van Eyck were a portrait of a Portuguese woman painted on cloth, now lost, and, by 1516, *The Arnolfini Portrait* (plate 3), both given to her by the Spanish nobleman Diego de Guevara. She also possessed a version of van Eyck's *Virgin by a Fountain* (1439; Koninklijk Museum voor Schone Kunsten, Antwerp).

While some Netherlandish painters were employed at court, the majority lived and worked in the towns. The burgeoning economy of the period meant that the principal towns of the Burgundian Netherlands had developed into wealthy, densely inhabited centres of commerce and trade, and each town provided unique opportunities for patronage. In the important centre of Bruges, one of the main residences of the Burgundian court (along with Brussels), the domestic market for art was substantial. Painters received commissions from

nobles, administrators and court bureaucrats, as well as from the town's wealthy patricians, commercial middle classes and successful artisans. It was painters' access to the community of international merchants and bankers, however, which transformed the scope of their production. Bruges brought together in one place merchants from across Europe, producing limitless opportunities for the exchange of goods. Established into groups according to their places of origin, the merchants drew up statutes and obtained privileges, gaining a measure of legal protection and authority to support their activities. Among the most important were the Hanseatic League (an association of great trading towns of the Baltic and North Germany) and the representatives of Iberia (Castile, Aragon, Navarre, Portugal), Italy (Venice, Genoa, Lucca, Milan and Florence), England and Scotland. Between 1439 and 1478 Bruges was also an important centre within the banking empire of the Medici, the powerful family of merchant-bankers who controlled the government of Florence. Moreover, although few French merchants resided in Bruges, trade with France, both by land and by sea, was vigorous in this period.

The internationalism of Bruges is reflected in the patronage of its painters. Jan van Eyck's *Arnolfini Portrait* (plate 3), for example, was commissioned by a member of the Arnolfini family, from Lucca in Tuscany. Among the various identifications proposed for the sitters, one candidate is the Lucchese merchant Giovanni di Nicolao Arnolfini, in Bruges by 1419, who regularly supplied Philip the Good with cloth of gold and silks between 1424 and 1427 and may have known van Eyck well. Hans Memling's paintings *Saint John the Baptist* and *Saint Lawrence* (plate 17) were the wings of a triptych probably made for the Florentine friar, later a bishop, Benedetto Pagagnotti (died 1523). Interestingly, these saints were venerated by various members of the Medici family, with whom Pagagnotti had close familial and political ties, and may have been chosen in honour of the Medici. Alternatively, the painting may have been a gift from one of the Medici to Pagagnotti. In such transactions, international merchants in Bruges could act as intermediaries by placing commissions on behalf of family members, colleagues or allies. Finally, the Welshman Sir John Donne (died 1503), a diplomat at the English court of Edward IV, emulated the taste of the duke of Burgundy and his nobles by commissioning Hans Memling to paint a triptych for him (plate 16). The consumption of art among all these various groups, whether courtiers, local burghers or international businessmen, was driven at least in part by their desire to assert their social status through the ownership of prestigious works of art.

THE GROWTH OF THE OPEN MARKET

Market forces of supply and demand fuelled an escalation in open-market production at this period, with painters making finished pictures without having identified a buyer, to be sold either directly from the workshop or at a market stall. Antwerp was at the forefront of the construction of specialised *panden*, sales halls designed expressly for the buying and selling of luxury goods, including paintings. Like Bruges, at certain times every year it held huge commercial fairs, which lasted for several weeks and were attended by merchants from all over Europe. Large numbers of finished paintings, drawn from the stock of both local and regional painters, were sold by artists and art dealers – indeed, many artists were dealers themselves, and would have been among the avid consumers of paintings at the fairs, where they could also buy frames, panels and other materials.

Being light and flexible and thus easily rolled up and transported, cloth paintings formed a significant percentage of paintings exported from the Netherlands. A major centre of manufacture was the port of Bruges, where, packed in bales or barrels, canvases could easily be loaded onto ships. Cheaper than panel paintings, the majority of cloth paintings were painted in glue-size, though oil on cloth was also in use. Over the course of the fifteenth century thousands of cloth paintings were sold on the open market in England, Italy and elsewhere. So few have survived and so greatly have the survivors suffered that it is impossible to gauge the full significance of the medium. Cloth paintings seem to have covered a wider range of subjects than panel paintings, however, and included not only scenes from the Old Testament but also erotic themes, subjects of entertainment such as morris dancing, tavern scenes and carnivals and, not least, landscapes and animal pictures.

Some cloth paintings were made on commission. *The Entombment* (plate 12) by Dirk Bouts, made in glue-size, is a fragment of a polyptych, a rare format for cloth painting. It was probably made for export to Venice. *The Four Elements* (plates 51–4), large-scale oil paintings by the Antwerp painter Joachim Beuckelaer, were probably commissioned by a wealthy Portuguese trader and were perhaps painted on fabric rather than wooden panels in the expectation that they would ultimately be shipped abroad.

PRODUCTION AND MARKETING

The centre of production was the painter's workshop. A master's workshop consisted of lodgings for himself, his family and his assistants, a studio or workplace and a shop window for the display of finished paintings. In order to sell his work in a particular town a master painter normally had to join the guild of painters, the body that governed and regulated the profession of painting in the locality. In his workshop he would employ assistants of two main types: young apprentices, still learning the craft, and journeymen, fully trained assistants who had not yet become master painters in their own right. In order to preserve

homogeneity of style in the workshop, the assistants would imitate the master's style as closely as possible. This often makes it a difficult task, as well as an anachronistic one, to make distinctions between the hand of the master and those of his assistants.

In the National Gallery Collection it is possible to detect different types of participation by assistants in the output of Rogier van der Weyden. *The Exhumation of Saint Hubert* (late 1430s; plate 9) and *Pietà* (probably about 1465; plate 10) belong to opposite ends of Rogier's career in Brussels, where, by 1436, he was town painter. In *The Exhumation of Saint Hubert*, the variations in style and abrupt contrasts of scale within a relatively shallow space and the large number of alterations to the secondary figures, made during various stages of painting, suggest workshop collaboration. The visual discrepancies suggest a date in the late 1430s, before Rogier had fully streamlined his workshop's operations. *Pietà*, by contrast, indicates that towards the end of his career, in the mid-1460s, he had introduced various efficient systems into his workshop practice. Existing in several versions, the *Pietà* is a reversed and simplified copy of the figure of Christ in Rogier's renowned *Miraflores Triptych* of about 1440 (Staatliche Museen zu Berlin, Gemäldegalerie, Berlin). He probably resized and adapted the design in order to produce a workshop model from which his assistants could make copies and variations. While the central figure group was repeated in all versions, the accompanying saints and donors were changed: each client could thus customise the basic image as desired.

Although a court painter could in principle remove himself from the world of the marketplace if his position was secure, by the mid-1430s Jan van Eyck had organised his workshop to produce copies and variations after his designs to meet what must have been, at this point of his career, a phenomenal level of demand. *Saint Francis receiving the Stigmata* (fig. 7), among other paintings, is in all likelihood the work of a highly trained workshop assistant.

Painters in early sixteenth-century Antwerp evolved innovative and complex ways of making and marketing paintings. These artistic developments resulted from Antwerp's rise, in the early sixteenth century, to become the greatest mercantile and artistic centre of Northern Europe, propelled by a rapid expansion of its overseas markets and a meteoric growth in its population. The most entrepreneurial among the city's painters tended to become specialists in a limited number of genres, which would be easily identifiable on the open market. Attentive to the demands of the commercial market and eager to attract buyers, they could play to the market by creating new picture types or by inventing new ways of treating traditional subjects. Building on existing workshop practices, artists made successful picture types in multiple copies and variant

images derived from one or more prototypes kept in the workshop. The workshop of Joos van Cleve produced large numbers of pictures of the Holy Family (see plate 43), forming a sub-specialisation within his oeuvre. Many variations were made of this composition, probably by van Cleve's assistants on the basis of pre-existing models. Although workshop assistants were skilled at copying models to scale by hand, from around the 1470s there is evidence of time-saving mechanical processes such as tracing, an efficient practice adopted, in some instances, to reduce the costs of outlay, increase turnover and thus maximise profit.

A specialism that proved a huge success for Joachim Patinir was landscape painting – or, since this was not yet an established genre, images of saints with landscapes (see fig. 18 and *Saint Jerome in a Rocky Landscape*, plate 45). Patinir's paintings of Saint Jerome, which he produced in multiple versions, show the saint inhabiting a typically vast, panoramic 'world landscape', seen from an elevated

FIG. 18
Joachim Patinir
(active 1515; died no
later than 1524)
*Landscape with Saint
Jerome*, about 1516–17
Oil on panel,
74 × 91 cm
Museo Nacional del
Prado, Madrid (1614)

viewpoint. The evolution of landscape painting was rooted in meditative traditions, as suggested by *Saint Francis receiving the Stigmata* (fig. 7) from van Eyck's workshop. Yet landscape scenes would also have been admired for their beauty, imagination and variety, and perhaps for their affirmation of Antwerp's new presence in global maritime trade through their depictions of harbours and sailing ships. The popularity of landscape painting from Antwerp, both locally and internationally, ensured the survival and development of the genre through the remainder of the sixteenth century. When in 1525 the painter and dealer Matteo del Nassaro returned from France to Italy with paintings to resell, he took with him '... in particular some landscapes painted in Flanders in oil and in gouache and executed by very able hands'.

Secular moralising pictures, some of which played to the commercial culture of the city, were among the best sellers of the period. A highly successful market niche was created by Marinus van Reymerswaele with his images of tax collectors: in his *Two Tax Gatherers* (plate 48) the grotesque, animalistic snarl of the man on the right is used to convey his inner greed and avarice. Quinten Massys's satirical *An Old Woman ('The Ugly Duchess')* (plate 32) makes the woman an object of mockery. Wearing ludicrous, outmoded costume and proffering an unopened rosebud between her unsightly, shrivelled breasts, she is held up here as a personification of the sin of lust. The painting recalls Erasmus of Rotterdam's attacks on vain and lustful old women in his *Praise of Folly* (1512): 'They painstakingly make up their faces. They can hardly pull themselves away from a mirror. They pluck out hairs from the strangest places. They show off their withered and flabby breasts. And, with a quivering voice, they try to stir up a faint desire.'

Another picture type developed later in the century, appearing from around 1550, was the 'market scene', which made the buying and selling of commodities, and their moral dimensions, the subject matter of art. Lavish displays of comestibles in the foreground are juxtaposed with small-scale biblical scenes in the background: in Joachim Beuckelaer's *Air*, one of a set of four scenes in which foodstuffs are linked with the four elements (plates 51–4), the Prodigal Son is shown cavorting with two women amid products from the market, perhaps associating the purchases with sin and over-indulgence.

THE NUDE FIGURE

A well-known commentary published in 1456 by the Italian humanist scholar Bartolommeo Fazio (about 1400–1457) describes a lost painting by van Eyck showing 'women of uncommon beauty emerging from the bath'. A lost picture of a nude woman bathing reminiscent of that admired by Fazio, evidently by Jan van Eyck, is depicted in a painting by Willem van Haecht (1593–1637), *The Art Gallery of Cornelis van der Geest* (fig. 19). The lost work was no doubt made primarily to give pleasure rather than to encourage moral reflection: the alternative view of the woman's body, seen from a different angle in the mirror, only emphasises the display of nudity. That the picture was erotic in intention is affirmed by contemporary Italian descriptions of 'precious foreign cloths painted with most beautiful figures of great immodesty' – presumably Netherlandish cloth paintings – which perished in the famous 1497 'Bonfire of the Vanities' staged in Florence by the radical preacher and reformer Girolamo Savonarola (1452–1498).

FIG. 19
Willem van Haecht
(1593–1637)
*The Art Gallery
of Cornelis van der
Geest*, 1628, detail
showing a painting
by Jan van Eyck
Oil on panel,
102.5 × 137.5 cm
Rubenshuis,
Antwerp

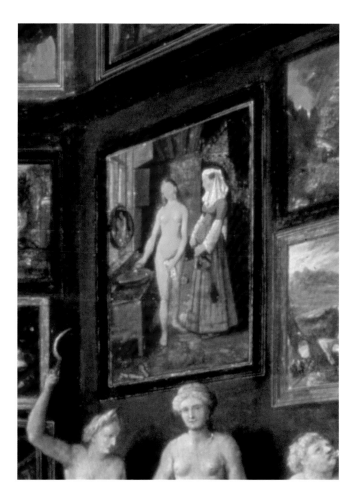

Erotic nudes by Netherlandish painters evidently attracted great interest among painters and patrons in Renaissance Italy.

In the early sixteenth century, conversely, Netherlandish artists began to study classical forms of the nude derived from the art of antiquity. According to Ludovico Guicciardini (1521–1589), writing in the 1560s, Jan Gossaert was the first painter to introduce to the Netherlands the art of painting 'historie e poesie con figure nude' – historical and mythological subjects with nude figures. Several pictures by Gossaert support this claim. These reflect the taste of his patron, Philip of Burgundy (1464–1524), a passionate lover of antiquity whose court was a centre of humanism. Philip, the youngest illegitimate son of Philip the Good, Duke of Burgundy, was also Admiral of the Habsburg Fleet and a highly sophisticated patron of the arts; as part of his education at the Burgundian court he had learnt not only the art of working gold, but also painting and drawing. It was the humanistic culture of Philip's court which led Gossaert, from 1516, to adopt the Latinised signature 'Ioannes Malbodius', in the manner of humanist poets and scholars (see fig. 14).

In 1508 Philip took Gossaert to Rome as part of a diplomatic mission, charging him to make drawings of the ancient monuments there. A pen-and-ink representation of the famous bronze statue of the *Spinario* (then displayed on a column) is one of the few surviving drawings from the mission (fig. 20). Gossaert seems to have responded to, and perhaps heightened, the casualness of the boy's pose, but he was most interested in its complex angularity, and in conveying the interplay between crisp outline and plastic form: the drawing records his personal reaction to the ancient statue. On the right, there is a drawing of a leg wearing an elaborate leather boot (from a colossal statue known as the 'Genius' discovered in the Baths of Caracalla), at the top, there is a parade helmet and lions' heads that probably adorned sarcophagi or other monuments. Gossaert evidently aimed to amass a range of such novel and fashionable ornamental motifs which could be reused as needed.

On his return to the Netherlands, Gossaert pursued his interest in the classical nude by consulting a rich variety of models, including prints by Marcantonio Raimondi (about 1480–1534), a reproductive engraver who worked in collaboration with Raphael in Rome; the Venetian Jacopo de' Barbari and, above all, the German painter and printmaker Albrecht Dürer (1471–1528). Prints played a vital role in the dissemination of classicising art. The vocabulary of Italian Renaissance art was imported into the Netherlands even before Gossaert's mission to Italy, not only through immigrant Italian artists (including the medallist Giovanni Candida, who worked at the Burgundian court and, later, de' Barbari) but also, more crucially, through portable works of art such as medals,

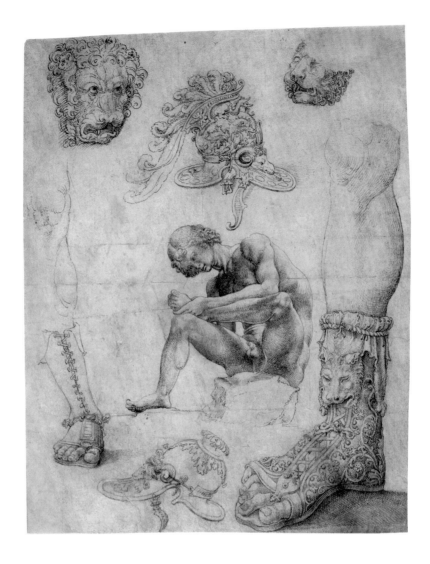

engravings and printed books that carried visual information north (the classical frieze shown in a Netherlandish picture in the National Gallery, dating from around 1510, must also derive from an Italian model: see *Christ presented to the People*, plate 29, by the Master of the Bruges Passion Scenes).

Gossaert also looked at sculpted nudes, including those by the German artist Conrat Meit (about 1480–1550), who worked for Philip of Burgundy between 1511 and 1514 and became court sculptor to Margaret of Austria. Meit specialised in making small-scale, sensuous nude figures in fine-grained materials which were appealing to the touch as well as the eye: a particularly fine example is his *Judith and Holofernes* (fig. 21), in which the selective colour serves only to heighten the beauty of the luminous alabaster. Something of the aesthetic of Meit's sculptures – their combination of highly finished surfaces and refined decorative detailing – is found

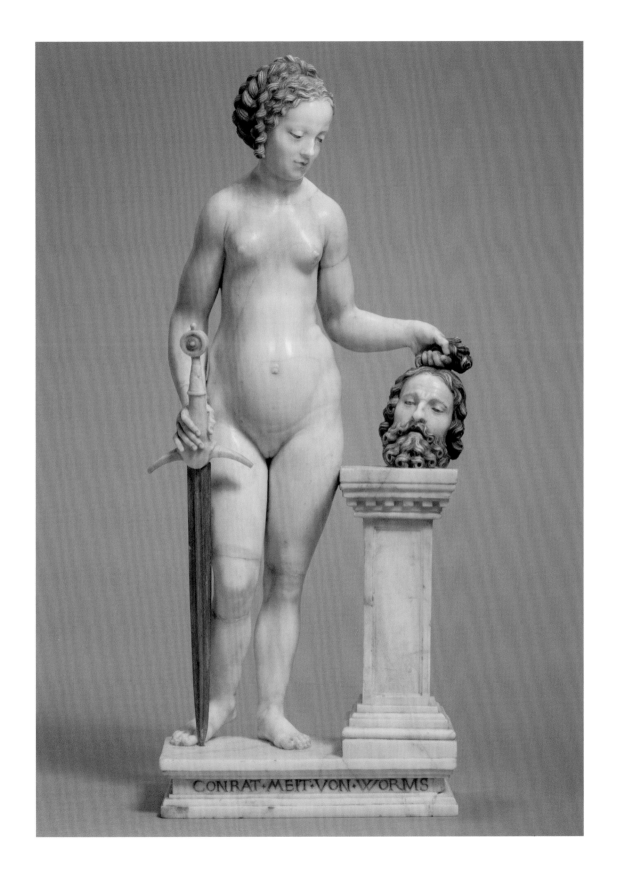

CONRAT·MEIT·VON·WORMS

in Gossaert's painted nudes. For example, *Danaë* (fig. 14) revisits a subject treated by ancient artists: according to Greek mythology, Danaë, daughter of King Acrisius of Argos, was sealed in a bronze tower designed by her father to keep suitors away, when Jupiter appeared to her as a shower of golden rain. Until recently Gossaert's painting was widely thought to be moralistic and didactic in intention rather than erotic, and to derive from an image type called the *pudicitia*, the embodiment of sexual virtue. But the eroticism of *Danaë* is clear, from her slightly parted lips and her drapery shown slipping off her shoulders to the linear play of the black ribbon, twisting in space against the curves of her breasts.

Erotic themes became a prevalent feature of early sixteenth-century Netherlandish art collections, where not only mythological figures but also biblical heroines such as Judith (fig. 21 and plate 46) and those from ancient Roman history such as Lucretia, were often portrayed nude. Some of the images present a deliberate ambiguity, encouraging the viewer to applaud the virtue or heroism of the figure while admiring her nudity.

COPYING VAN EYCK

For many painters of the late fifteenth and early sixteenth centuries the most important artistic model in the Netherlandish tradition was Jan van Eyck. When in 1495 a German doctor named Hieronymus Münzer (died 1508) went to see van Eyck's famous *Ghent Altarpiece* (begun by his brother Hubert van Eyck [died 1426]; Church of St Bavo, Ghent), the canons of the church told him that another great painter had desired so much to emulate the work that he became '*melancholicus et insipiens*' (melancholy and mad). The artist in this story was probably none other than the renowned Ghent artist Hugo van der Goes (active 1467; died 1482; see fig. 10).

A copy of van Eyck's *Virgin in a Church* (fig. 22), part of a devotional diptych (fig. 23), is traditionally attributed to Gossaert. The patron, portrayed on the inner right wing, was one Antonio Siciliano – probably the man of this name who was chamberlain and secretary to Maximilian Sforza (1493–1530), Duke of Milan. A comparison of the original with the copy shows numerous subtle changes. Most obviously, a section was added to the right-hand side of the design to place the Virgin more centrally within the space, and the patches of bright light on the church floor, which bring a mystical dimension to the painting, have been omitted. Unfortunately it is not known what was represented on the now-lost right-hand wing of van Eyck's diptych. The production of the copy was surely motivated in part by the devotional authority of van Eyck's image of the Virgin,

but it may also have been made in appreciation of its artistic and technical excellence. In 1513 Siciliano was in the Netherlands and at Margaret of Austria's palace in Mechelen on a diplomatic mission. He may have gained access to Gossaert, and perhaps to van Eyck's painting, through Margaret. In any case, his connection with the court brought him into highly sophisticated circles of art patronage and collecting where paintings were admired as works of art in themselves, regardless of their original functions as portraits, devotional images or altarpieces. In her collection, for example, Margaret had a small-scale copy of the famous antique statue of the *Spinario* (a drawing by Gossaert of the same statue is shown in fig. 20), the sort of object made for collectors and put on display as an artistic exemplar.

Gossaert's diptych is also likely to have been an object of fascination to art lovers. That he imitated the style of van Eyck's painting with so much care and precision suggests his intense interest in its aesthetic and technical qualities. The copy seems to have been made in a spirit of homage to van Eyck, and perhaps in competition with him. Interestingly, Margaret of Austria paid Gossaert for restoring unspecified paintings in her collection in 1523: it is possible that one or more of these was a painting by van Eyck. The binary form of the diptych is exploited to offer a series of contrasts to the observer: it evokes the eternal world on one side and the temporal world on the other; the gloom of an interior is set against a dazzling landscape, a time-honoured image against a fashionable panoramic view. The contrast between the tight detailing of the church architecture and the soft, melting horizon of the distant landscape was made possible by the sort of expert manipulation of the oil medium that would have been admired by collectors. Made to fulfil the desires and aspirations of a foreign buyer, it represents a complex and fascinating moment in the development of art appreciation and collecting.

In this context the diptych can be understood as a showpiece, designed to display the range of Netherlandish painting, its sophistication, complexity and technical versatility. For here we see, in one object, the precisely rendered portrait, the sense of vast spatial depth in landscape, the atmospheric distances and spiritual power of Netherlandish painting. That it holds up van Eyck as an artistic exemplar serves to underscore his importance within the tradition. And, indeed, the rise of oil painting to one of the most prized media of the Renaissance rested in large part on the achievements of van Eyck and his contemporaries.

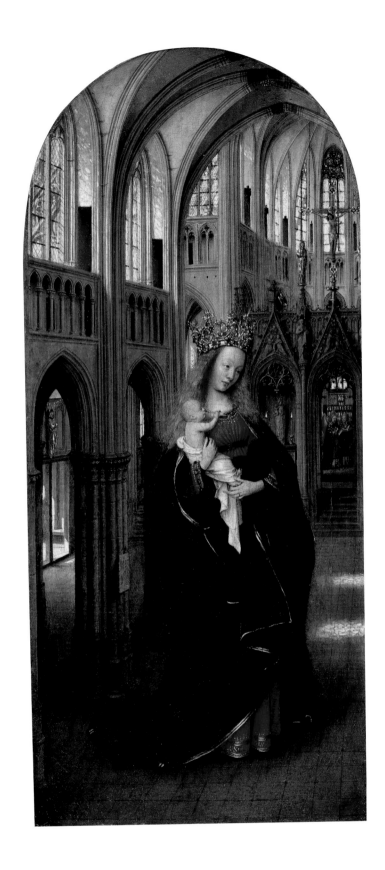

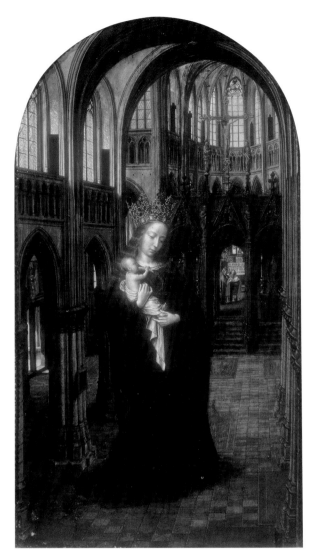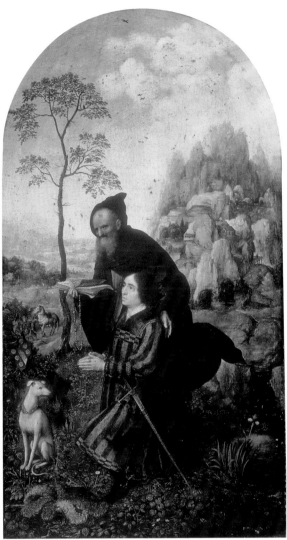

FIG. 23
Attributed to Jan Gossaert (active 1503; died 1532)
Diptych, about 1513, open view: copy of Jan van
Eyck's *Virgin in a Church* and *Saint Anthony with a
Donor* (*Antonio Siciliano*)
Oil on panel, each 40.2 × 22 cm
Galleria Doria Pamphilj, Rome

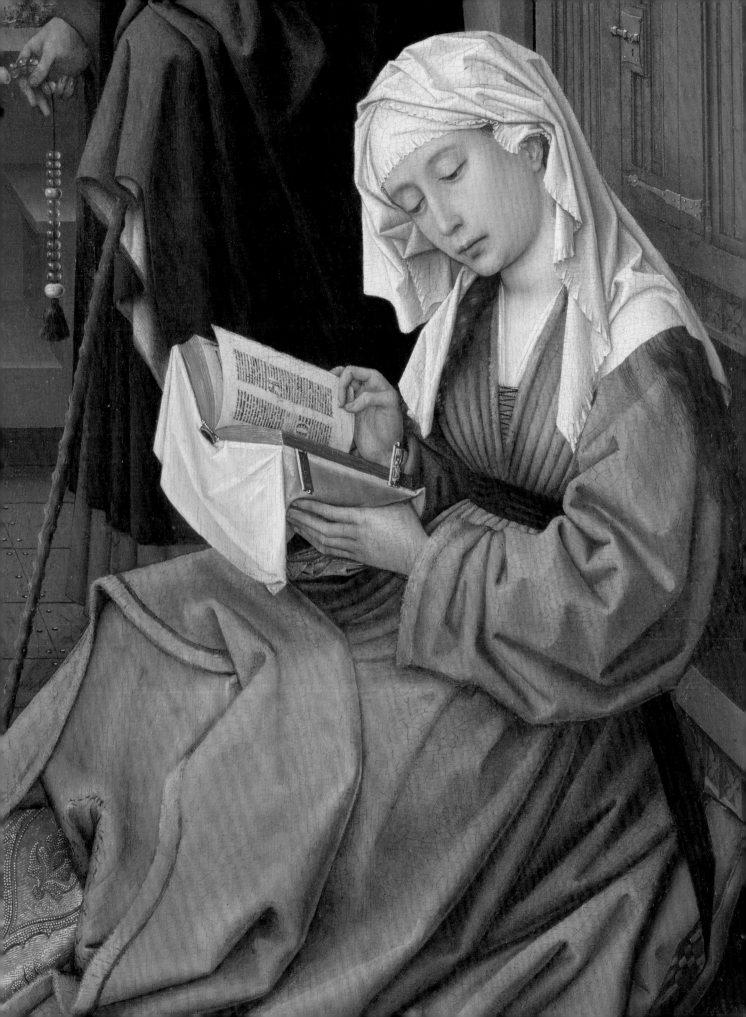

THE PAINTINGS

I

JAN VAN EYCK (ACTIVE 1422; DIED 1441)
Portrait of a Man ('Léal Souvenir')

1432
Oil on oak, 33.3 × 18.9 cm
NG 290

The man's identity is not known. He is presented as though behind a fictive parapet, on which is inscribed, as if carved in stone, 'LEAL SOVVENIR' (Loyal Remembrance). This may simply indicate that the portrait is an accurate likeness but it could mean that it is a posthumous portrait. The chips and fissures in the stone, which suggest the passage of time, may be intended as a reminder of the transience of life.

The composition with the parapet may have derived from ancient Roman tombstones, which van Eyck could have seen in Burgundy and France. These show an image of the deceased behind a parapet, holding a basic attribute, such as a sword, writing tablet or hammer, along with a carved inscription. Highly unusual for a fictive carving by van Eyck is the absence of punctuation for the words 'LEAL SOVVENIR'; this could also derive from these ancient precedents. For these words van Eyck used a script which has been dated to the twelfth century, one which he frequently used; here, he elaborated it to produce an elegant effect.

At the top of the parapet is the tiny Greek inscription 'ΤΥΜ· ΩΘΕΟΙ'. This has long been interpreted to read 'Timotheos', identifying the sitter as a second Timotheos of Miletus, a famed ancient Greek musician and rhetorician. In this case, the punctuation mark in the centre of the inscription may have been intended to demarcate the name of God 'OTHEOS' within the name Timotheos, creating a sort of *double entendre*. More recently, however, it has been proposed that the inscription is a Greek version of the Latin letters 'TUM. OTHEOS', meaning 'Then God', a possible reference to the afterlife.

Whatever the full meaning of the painting, its probable allusion to ancient tomb stones, its cryptographic reference to Greek and its use of the French language make it likely that it originated at the sophisticated Burgundian court.

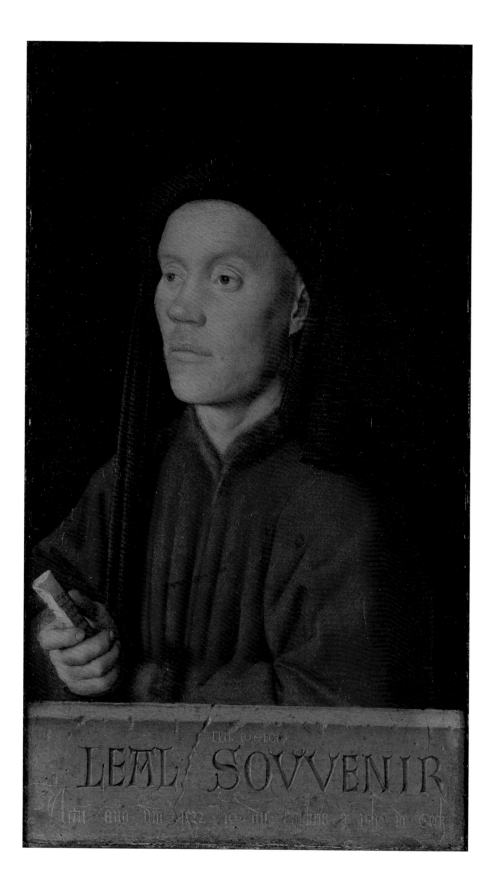

JAN VAN EYCK (ACTIVE 1422; DIED 1441)

Portrait of a Man (Self Portrait?)

1433
Oil on oak, 26 × 19 cm
NG 222

The position of the word '*ich*' in the motto directly above the sitter's head suggests that this is a self portrait of Jan van Eyck. It reads '*Als ich can*' (As I can), incorporating a play on the word '*ich*' and 'Eyck'. This can be interpreted to mean 'As well as I can', signifying the painter's pride in his skill, but also his humility

The man appears to turn towards us, directly meeting our gaze, which lends the portrait a sense of immediacy and life. A convincing sense of volume is produced by the bold illumination of the head against a neutral, dark background. Emerging from deep shadow, the flamboyant red chaperon (a type of headgear) reads as a complex three-dimensional object in space. These lifelike effects are enhanced by van Eyck's astonishing powers of observation. Indeed, if this is van Eyck, he may have intended the piercing gaze to be understood as a metaphor for the painter's discriminating and confident scrutiny of the world. Much of the descriptive detailing is concentrated around the eyes, which are slightly bloodshot.

On the lower frame, the date is given to the day: '·M° CCCC°·33°·21·OCTOBRIS' (21 October 1433). Since an oil painting made using this multi-layered technique could not have been painted in one day, the significance of this way of dating is unclear. An expert but not pedantic painter, van Eyck did not plan carefully for the signature on the lower frame and ran out of space at the end. By contrast, he applied great thought to the design of the motto, as well as its potential to capture the viewer's interest. The Greek letters not only initiate a verbal game, but eliminate any curves from the motto's design, making it angular and rectilinear. Furthermore, the way in which it forms a triad of three-letter words produces a balanced design, while being reminiscent of inscriptions on some Eastern icons.

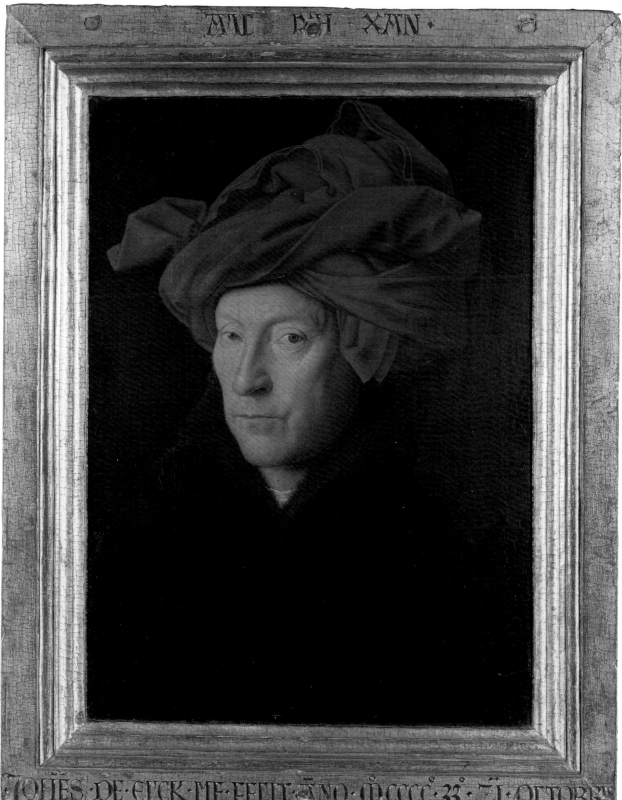

3

JAN VAN EYCK (ACTIVE 1422; DIED 1441)

Portrait of Giovanni(?) Arnolfini and his Wife (The Arnolfini Portrait)

1434
Oil on oak, 82.2 × 60 cm
NG 186

This double portrait is one of the most complex and innovative of all van Eyck's paintings. Descriptions of the picture from the early sixteenth century identify the man as a member of the Arnolfini family from Lucca, various members of which were in Bruges at this period. The most successful and prosperous was Giovanni di Arrigo Arnolfini (died 1472), chief supplier of luxury textiles to the Burgundian court and a familiar of Duke Philip the Good. Another possibility is his cousin, Giovanni di Nicolao Arnolfini (still living in Bruges in 1452), also a wealthy cloth merchant, whose fortunes declined during the later 1430s. The identity of the woman is unknown.

The portrait bespeaks the couple's high social standing and affluence. Most notable among the prestigious objects on display are the tester bed hung with red woollen cloth; the ten-sided convex glass mirror, which is unusually large and complex; and the very costly polished brass chandelier. Even the oranges, which were expensive at this period, are status symbols. The woman's green wool dress has elaborate dagged sleeves and a notably long train arranged in thick folds across the floor. It is lined with white fur of an impossibly even colour for the time; it may be ermine or pured miniver (squirrel belly fur).

In the centre of the picture van Eyck proclaims his presence with the phrase *'Johannes de eyck fuit hic'* (Jan van Eyck was here). From the calligraphic lettering, highly crafted and artificial, we can infer the craftsmanship that was required to make such a painting. The mirror below reflects the figure of van Eyck, standing in the doorway, about to descend the stairs into the room. While the significance of the formal gestures made by the couple has been controversial, it is arguable that the man is presenting the woman to the spectator, who, like van Eyck, is invited to enter the chamber.

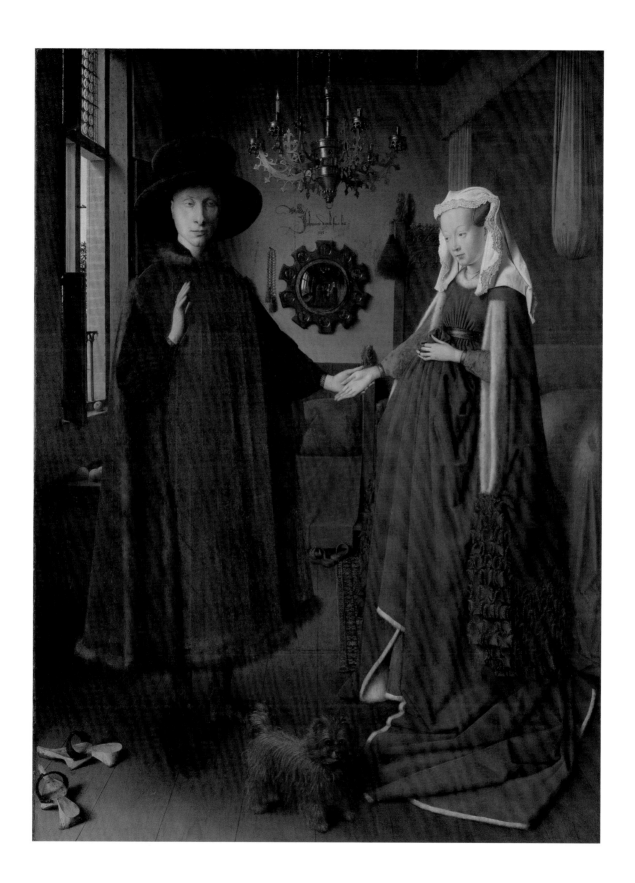

4, 5

ROBERT CAMPIN (LATE 1378/9−1444)

A Man

Oil with egg tempera on oak, 40.7 × 28.1 cm
About 1435
NG 653.1

A Woman

Oil with egg tempera on oak, 40.6 × 28.1 cm
About 1435
NG 653.2

Though Robert Campin is a well-documented painter, there is no consensus as to his oeuvre or the organisation of his workshop, which was established in Tournai (Hainaut). Some pictures assigned to an anonymous artist named the 'Master of Flémalle' have been attributed to him. This pair of portraits, showing middle-class townspeople of the 1430s, is among them.

These portraits are powerful images. The solid black backgrounds, strong lighting and dominance of the figures themselves − which virtually obscure their backgrounds − make the figures appear strongly three-dimensional. The limited, bold colour scheme is effective in connecting and balancing the two portraits, particularly where, at the inner edges, the diagonal lines of the red and white headdresses are visually linked. They also reveal Campin's interest in pattern-making. Thus the woman's eyes curve upwards, a movement echoed and continued in the multiple crisp edges of her headdress, while the man's sagging eyelids create downward-moving lines. Her eyes are bright; his are dim. These are artificial effects, planned by the painter, who designed the images to create a contrasting pair. It is not certain how these portraits were displayed, but the fact that their reverses are marbled in red and brown suggests that they did not hang against a wall.

Campin's skills in handling the oil medium are evident in his precise delineation of the tiny metal pins in the woman's headdress and in his ability to convey qualities such as the heaviness of her smooth veil (the material may be linen) and the softness of the grey fur trim of her sleeves. The flesh is modelled with clarity and exactitude. The sculptural power and precision of these portraits is characteristic of the artistic tradition of Tournai, which, along with that established by van Eyck in Bruges, was the most artistically significant in the Netherlands.

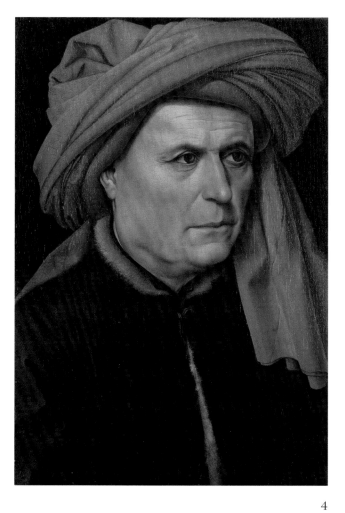

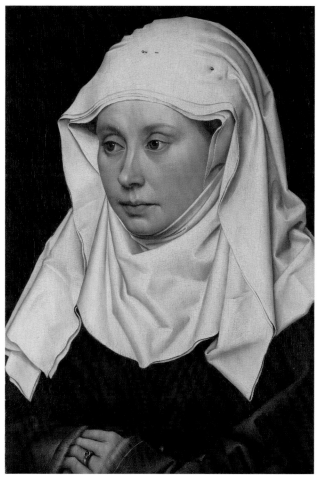

4

5

6

FOLLOWER OF ROBERT CAMPIN

The Virgin and Child before a Firescreen

About 1440
Oil with egg tempera on oak with walnut additions, 63.4 × 48.5 cm
NG 2609

The figure of the Virgin Mary, arranged along a strong diagonal running from lower left to upper right, dominates the chamber in which she is seated. Through the window is a town inhabited by tiny figures going about their daily lives; this suggests that the holy figures have entered the world of the spectator's experience. The direct outward gaze of the Christ Child implies that the Virgin's gesture of proffering her breast is extended to the viewer. Drops of milk are visible round the nipple. The Virgin's gesture refers to her special efficacy as an intercessor for mankind, rooted in the fact that, as Christ's earthly mother, she had nourished and cared for him in his infancy.

While many of the pictorial features in the chamber were no doubt observed from nature, the naturalistic light effects owe much to the painter's imagination. This is true of the reflected light on the triangular stool in front of the window, where the part of the leg rising above the horizontal bar reflects the orange light of the fire, and the lower part the white light of daylight. The furnishings are not typically middle class, as was once assumed, but fitting for a person of noble or royal rank. Wooden furniture was owned by members of all social classes but only in high-ranking households would they be adorned with such expensive silk cushions and fabrics.

Like many other Netherlandish paintings, this picture was probably commissioned or bought by an Italian patron, perhaps a member of the Balbiano family from Chieri in Piedmont (north Italy). Later in its history, in the late nineteenth century, the picture was physically altered, a wide addition being affixed to the right edge and a narrow one along the top edge. These additions have been visible since 1992–3, when the original part of the picture was cleaned, leaving the additions untreated.

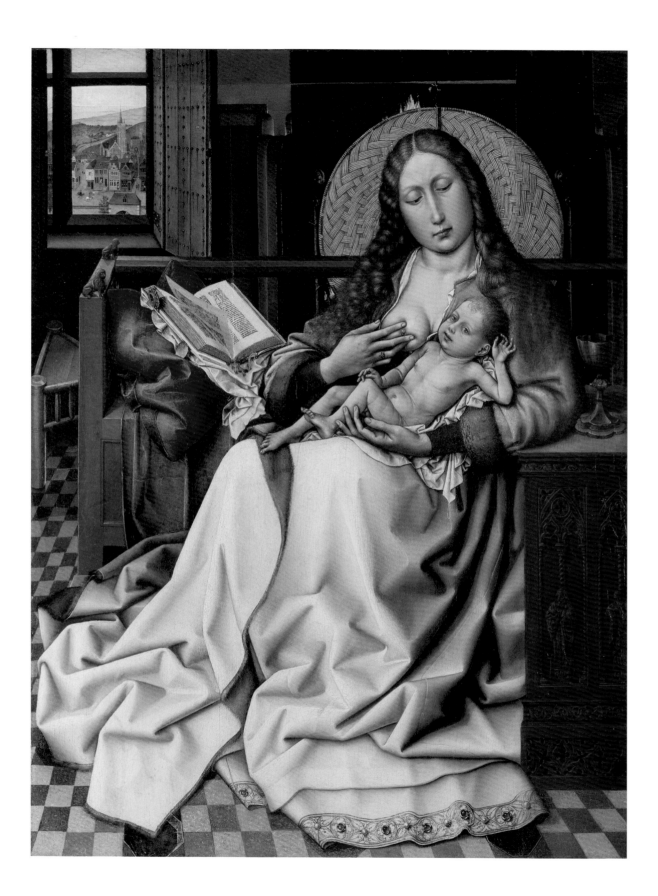

7

WORKSHOP OF ROBERT CAMPIN (JACQUES DARET?)

The Virgin and Child in an Interior

Before 1432
Oil on oak, 18.7 × 11.6 cm
NG 6514

This little fireside scene of warmth, care and love was intended to arouse tender feelings. The Virgin is in the process of bathing the Christ Child. Their faces are pressed together, the infant caressing Mary's chin while touching his genitals (a gesture obscured by damage): the obvious sexual overtones may allude to the Virgin's role as the Bride of Christ. That the Virgin is seated on a cushion close to the ground does not necessarily symbolise her humility, as this way of sitting was considered suitable for the highest nobility of the period. The cloth-of-gold cushion and matching textile, moreover, are high-status luxury items.

A variety of different light sources illuminate the chamber, including the bright daylight entering through the window, casting double shadows on the wall; the single candle on the chimney breast; and the roaring fire, with its smoking logs and floating embers. These naturalistic effects make the scene believable, though they may also have been chosen to advertise the painter's versatility and skill. The rays of divine light round the Virgin's head, by contrast, are represented by real gold. Perhaps the most notable feature of the painting, however, is Mary's blue robe, which is skilfully modelled in a wide range of tones and arranged into complex patterns of angular, interlocking folds, spread out broadly around the figure. These stiff, three-dimensional drapery folds find analogies in contemporary sculpture.

The wooden panel and frame were carved from a single piece of wood: the mouldings at the top and bottom undulate slightly because to create them the maker has had to cut across the grain of the hard oak. Portable and used for private devotion, the panel was originally marbled on the reverse in red, black and white, and the frame was possibly marbled too.

It has been suggested that the picture might be the work of Jacques Daret (about 1404 – about 1470), who was active in Campin's workshop.

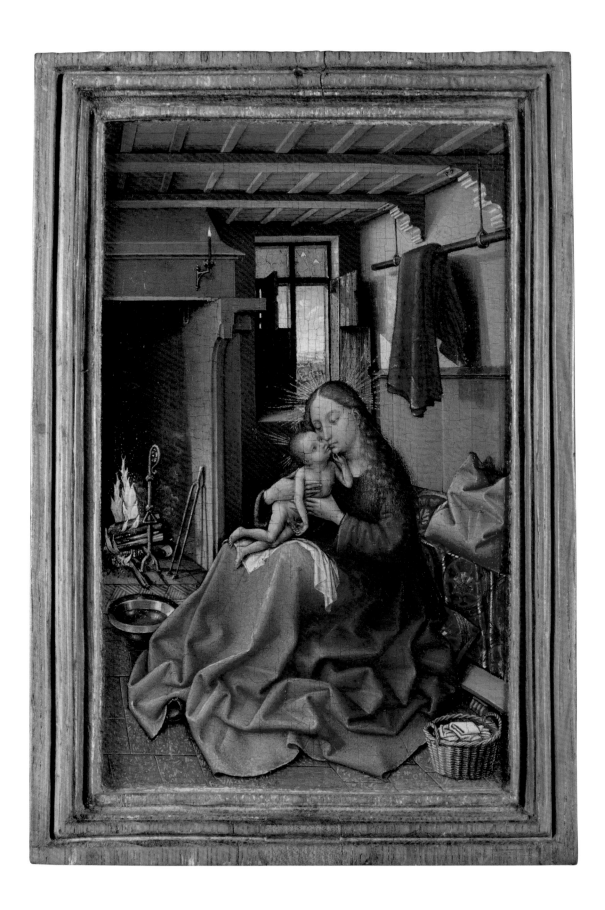

8

ROGIER VAN DER WEYDEN (ABOUT 1399–1464)

The Magdalen reading

Before 1438
Oil on mahogany, transferred from another panel, 62.2 × 54.4 cm
NG 654

This picture is a fragment from the lower right corner of a large altarpiece of the Virgin and Child enthroned with six saints. It shows parts of two of the other figures: Saint Joseph, standing behind the Magdalen, and Saint John the Evangelist, kneeling in red on the left.

The various types of Mary Magdalene in Western European painting derived from a rich accumulation of New Testament stories and apocrypha. This figure, shown reading, is based on the biblical figure of Mary of Bethany who, in Western biblical exegesis, was identified with Mary Magdalene (Luke 10: 38–42). Mary was regarded as an exemplar of the contemplative life, since she 'seated herself at the Lord's feet, and listened to his word', while her sister Martha, who complained to Christ that Mary should help her serve, represented the active life.

The figure's enclosure in a semicircular shape expresses her self-absorption: Rogier was a master at perceiving and developing such links between form and meaning. The painting also reveals his remarkable attention to detail, which can be compared to that of Jan van Eyck. In Rogier's painting, many of the smallest details – the highlights on the rosary beads held by Saint Joseph or the costumes of the tiny figures in the cultivated landscape – are painted with extraordinary care. In van Eyck's *Arnolfini Portrait*, by contrast, the highlights on the rosary beads hanging on the wall and other details such as the chandelier reflected in the mirror were executed rapidly, with a mere flourish of the brush, giving only the impression of detailed execution (see fig. 13, p. 22).

Active in Robert Campin's workshop by 1427, Rogier van der Weyden became a master of the guild of painters of Tournai in 1432. In Brussels by 1435, and for the remainder of his career, he nonetheless retained strong links to Tournai.

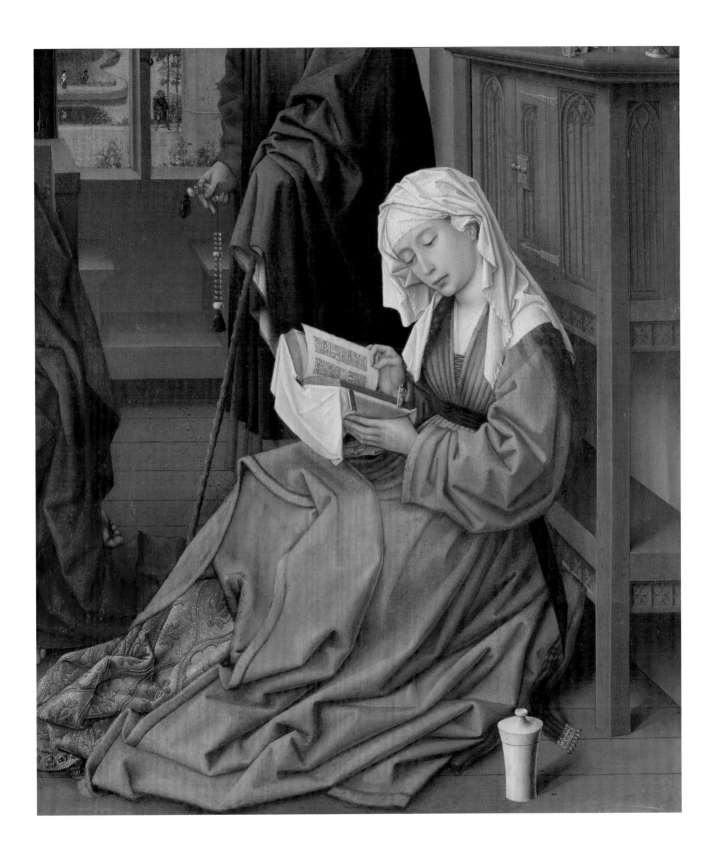

9

ROGIER VAN DER WEYDEN (ABOUT 1399–1464) AND WORKSHOP

The Exhumation of Saint Hubert

Late 1430s
Oil with egg tempera on oak, 88.2 × 81.2 cm
NG 783

This painting was commissioned in the late 1430s by Jan Coels and Jan Vrientschap to decorate a chapel they founded in the most important church in Brussels, St Gudula. Coels was a financier and receiver of the ducal domains for Philip the Good, Duke of Burgundy, and Vrientschap was a haberdasher from a prominent Brussels family. Their choice of painter was Rogier van der Weyden, newly arrived in Brussels (by 1435) but already a painter of repute.

In accordance with the chapel's dedication to Saint Hubert, Bishop of Maastricht and Liège (died 727), the painting depicts the second exhumation of the saint's body in 825. It was originally part of a larger structure such as an altarpiece, or, perhaps more likely, a narrative series.

Numerous changes were made during the course of production. A group of portrait heads was painted on top of (or overlapping) completely different, partially realised heads. It is likely that these depict the founders, and that they asked for their portraits to be included at a late stage: the older couple on the left are probably Jan Vrientschap and his wife, along with their five sons, and the younger couple directly to the right of the altar Jan Coels and his wife Catharina. This theory alone, however, does not fully account for the inconsistencies in scale among the heads of the mid-ground figures, or the discrepancies in the lighting: the portraits of Jan Coels and Catharina are lit from the right, whereas all the other figures around them are lit from the left. Overall, the inconsistencies suggest that the artists based the painted portraits on drawings kept in the workshop but did not make necessary adjustments in scale and lighting: Rogier van der Weyden presumably employed assistants to help complete this commission. His role was to produce the relevant designs, and perhaps also to paint the most important, foreground figures.

10

ATTRIBUTED TO THE WORKSHOP OF ROGIER VAN DER WEYDEN (ABOUT 1399–1464)

Pietà

Probably about 1465
Oil with egg tempera on oak, 35.5 × 45 cm
NG 6265

The *Pietà* (Our Lady of Pity) shows the Virgin embracing Christ's dead body. This episode was not mentioned in the Bible but is described in devotional texts such as the thirteenth-century *Meditations on the Life of Christ*. It extracts the two principal figures of the Virgin Mary and Christ from the broader narrative of the Lamentation, placing the focus entirely on the Virgin's feelings. The scene encouraged the spectator to look at – and even to feel – the dead Christ through the person of his mother.

When the owner of this image looked at it he saw a portrait of himself kneeling in prayer, his unfocused gaze suggesting that he has risen above the material world: he is using his spiritual rather than his bodily vision. The figure of Christ is positioned close to the patron and his little finger seems to graze the fur of his gown. The picture encouraged the patron to imagine, in his mind's eye, being physically close to the holy figures, experiencing this moment alongside them.

The patron was presumably especially devoted to the two saints present here, and asked them to be included: Saint Jerome appears on the left; the figure on the right is possibly Saint Dominic. The picture is thus a good example of a devotional image that was designed to meet the patron's personal specifications.

Netherlandish oil paintings such as this, in which the tears of Mary and the wounded body of Christ are convincingly depicted, were admired in Italy and elsewhere for their capacity to ignite intense spiritual feeling and empathy. They had an emotional power that less realistic images could not match. The fact that a fifteenth-century copy of this picture is in Sicily suggests that the owner may have been Italian.

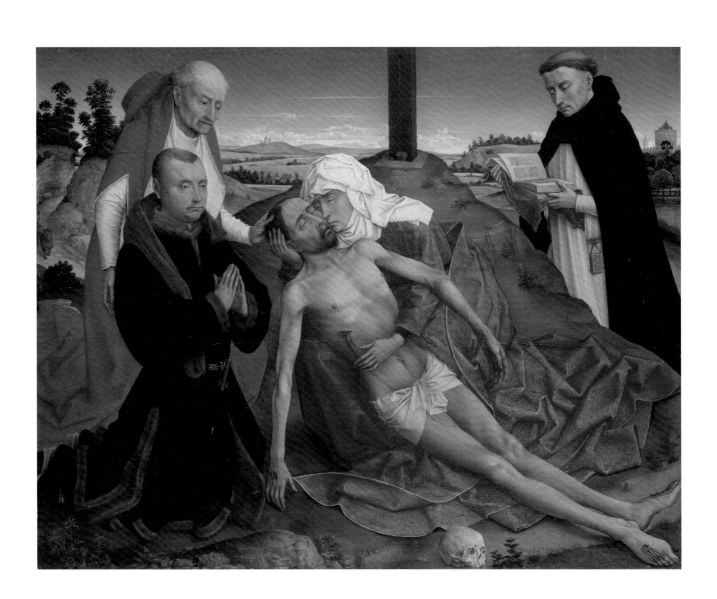

11

PETRUS CHRISTUS (ACTIVE 1444; DIED 1475/6)

Portrait of a Young Man

1450–60
Oil on oak, 35.4 × 26 cm
NG 2593

The man holds an open prayer book and gazes to the right, suggesting that an image of the Virgin and Child would originally have been hinged to this panel to form a diptych. Christus was interested in pictorial space and was among the first painters in portraiture to place his sitters in a corner space. Here, the man stands in the corner of a vaulted chamber, enlivened by the landscape glimpsed through the window and by the sculptural decoration of the doorway on the left

On the wall behind the man is an illuminated parchment showing an image of the revered icon known as the *veronica*, along with a prayer. The icon, a cloth miraculously imprinted with an image of Christ's face, was understood both as a vestige of Christ's life on earth and as confirmation of his divinity. The words of the accompanying prayer, 'Hail, Holy Face', implore the *veronica* to lead the viewer to heaven, that 'we may see the face of Christ himself'. Interested in minute description, Christus has shown the lower right corner of the parchment curled up, revealing the piece of wood to which it has been fixed with little metal pins: these run right round the image, pushed through the red ribbon that forms the border.

The doorway on the left is decorated with three stone statuettes in niches, along with an empty niche. The outer row contains statuettes of a prophet and a sibyl, figures who foretold the coming of Christ to the Jews and Gentiles respectively. The inner row shows a statue of Saint John the Baptist, the final herald of Christ. Collectively, the figures may represent the prophecies of Christ's coming, in which case the empty niche might signal the transition to the New Law.

An immigrant to Bruges, Petrus Christus established himself there as a master painter in the mid-1440s. To some extent he filled the gap in the market created by Jan van Eyck's death in 1441.

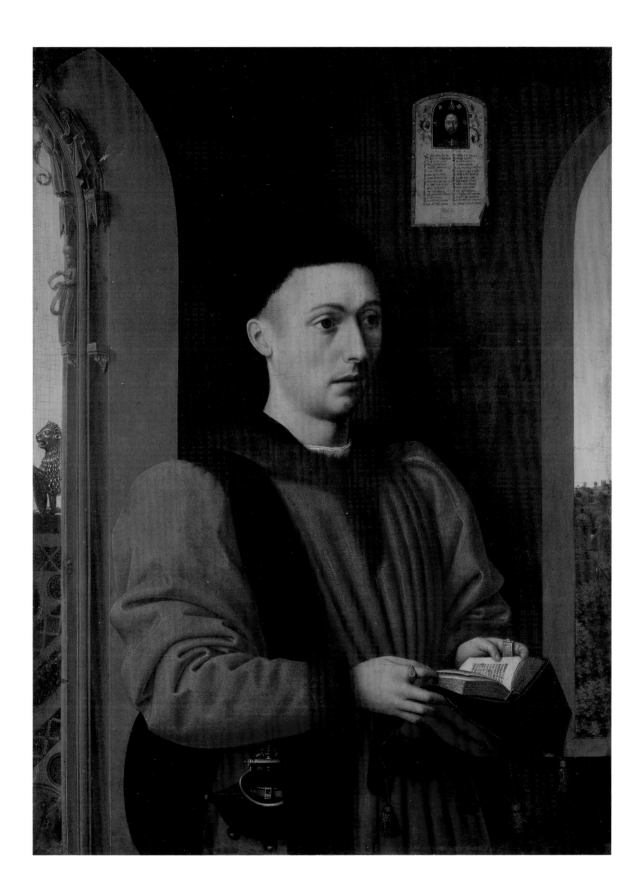

12

DIRK BOUTS (1400?–1475)

The Entombment

Probably 1450s
Glue-size on linen, 87.5 × 73.6 cm
NG 664

In this scene of Christ's Entombment, Bouts has represented a range of emotional states among the mourners, from restrained grief to lingering sorrow and tears. The man at Christ's feet is probably Joseph of Arimathea, who obtained Christ's body from Pilate, wrapped it in linen and laid it in his own tomb, near Golgotha. Behind the foreground stage, a winding pathway and broad, shining river lead the eye to a vista of far-off hills and trees receding to the horizon. The dullness of the landscape appears to suit the subject matter – but the effect is misleading. *The Entombment* is painted in a glue-size medium on a finely woven cloth and the colours have altered greatly over time. Originally the sky would have appeared the same clear, pale blue colour that is visible in a strip along the top of the painting, where the fabric has been protected by a frame. Since colours mixed in glue-size are less durable than oil colours, paintings made in this medium were sometimes protected by curtains or, if small, placed under glass.

The painting was part of an altarpiece of the Crucifixion, which was perhaps ordered by a Venetian patron. A brown border was painted around the image on all four sides after the painting was finished, probably a guide line for the position of the frame. Both the frame and the linen cloth on which the picture was painted would have been affixed to a wooden support at the same time, using nails or pegs. That a row of holes runs across the area of the sky, within the pictorial field, suggests that in this case the frame was positioned lower than Bouts himself intended. It is possible that the frame was applied – and the whole altarpiece assembled – once the painting had arrived at its destination.

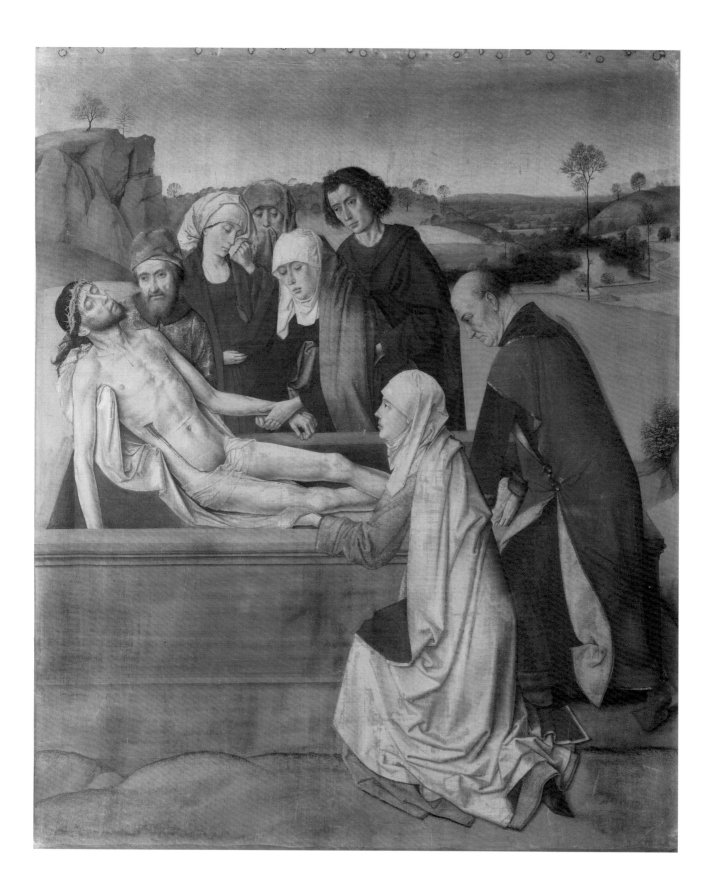

13

DIRK BOUTS (1400?–1475)

The Virgin and Child

About 1465
Oil with egg tempera on oak, 37.1 × 27.6 cm
NG 2595

The Virgin and Child present themselves to the viewer as if at a window opening. They appear to have entered our world, yet the setting is unusually sumptuous – the cloth hanging behind the Virgin and the cushion on the sill are both made of cloth-of-gold. The window setting, along with the opulent fabrics, parallels the way in which contemporary princes showed themselves to their subjects, identifying this nursing mother as the Queen of Heaven. The splendour of the scene is reinforced by the painter's use of consciously beautiful colour combinations, exemplified by the juxtaposition of two closely related deep blues, a rich purple and white in the Virgin's costume.

The subject of the Virgin nursing the Child expresses the humanity of Christ and underscores Mary's role as an effective intercessor, founded on her care and nourishment of her son. It thus responded to the patron's needs for private devotion. Despite the splendour of the setting, the imagery emphasises the humanity and accessibility of the holy figures. The Virgin wears no jewels or pearls and her headband, robe and mantle are all unadorned. The direct gaze of the child, along with his animated, open gestures, makes him a responsive figure. At the lower edge of the painting, moreover, the cushion and white cloth appear to protrude into our space. All these details humanise the figures, making them appear close and accessible – effects no doubt desirable in the context of private prayer.

The design is based on strong geometric shapes, including the rectangles of the windows and of the cloth of honour (a cloth displayed as a sign of high rank), itself subdivided into further rectangles. The balanced composition, in which the Virgin and Child face in different directions, suggests that the painting was always intended as an independent panel, rather than part of a diptych.

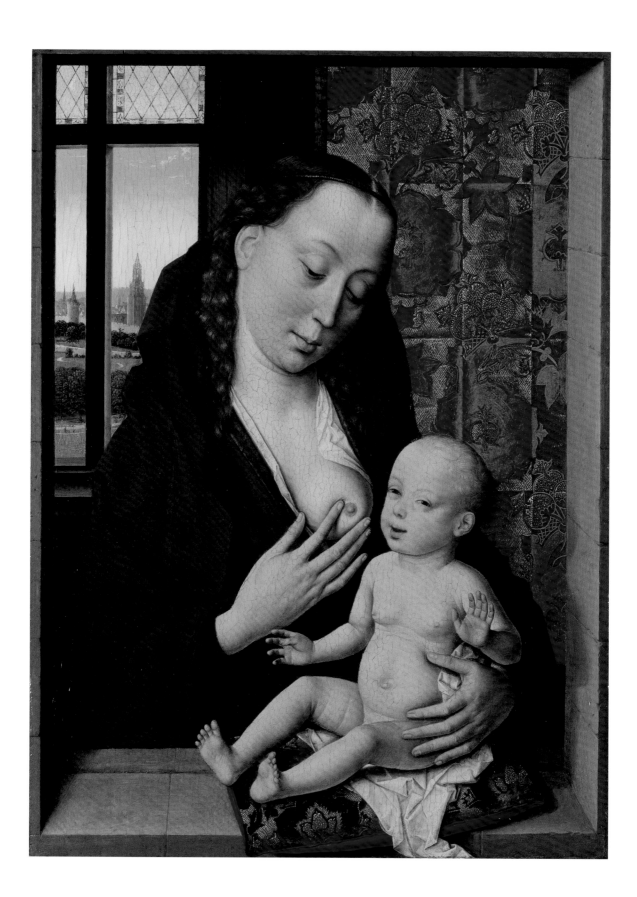

14

DIRK BOUTS (1400?–1475)

Christ crowned with Thorns

About 1470
Oil with egg tempera on canvas backed on to board, transferred from wood, 43.8 × 37.1 cm
NG 1083

The depiction of extreme suffering, incorporating a graphic rendition of Christ's wounds, was common in painting of the fourteenth and fifteenth centuries. Such images were apparently in tune with the religious sensibilities of the time, since images of Christ weeping were made in large numbers. Here, the thorns digging into his forehead and weaving in and out of his flesh are an important focal point. The imagery relates to prayers associated with the *Devotio Moderna* (Modern Devotion), a contemporary religious movement in the Netherlands whose adherents immersed themselves in Christ's earthly life and sufferings. One of their prayers speaks of the 'most grievous sufferings which, in the thorny coronation of Your sacred head, You endured for us …' The realism of Netherlandish painting made such images of the suffering Christ astonishingly vivid and lifelike, most obviously here in the remarkably three-dimensional, tactile wounds of Christ. Illustrating that Christ continues to suffer for our sins, they seem still to be bleeding.

Christ is depicted against a background of gold leaf flecked with painted dots and hatched lines. This technique creates a sense of shallow space as well as exalting Christ's divinity by creating a halo of gold, red, green and blue rings around his head, seemingly in flickering movement. Displayed against gold, Christ is extracted from the historical narrative of his Passion and Crucifixion, an effect underscored by the fact that, although he has already been crucified, he wears the scarlet robe he was wearing before the Crucifixion, when he was mocked by the soldiers. The imagery thus allows the user to consider several themes of the Passion in a single devotional object.

The half-length format and gold background accord with the ultimate origins of this image type in Byzantine icons, which exerted an important influence on Western panel painting.

15

DIRK BOUTS (1400?–1475)

Portrait of a Man (Jan van Winckele?)

1462
Oil with egg tempera on oak, 31.6 × 20.5 cm
NG 943

The sitter occupies an interior space containing a window that opens onto an urban landscape. The sensitivity of the modelling and its subtle colouration, in which the man's lips contain the faintest echo of the purple of his costume, is characteristic of Bouts. A sharp silhouette is obtained by the interplay of light and dark, most obviously by setting the undulating edge of the man's pale face against the dark glass of the window.

The original frame is lost but the man's fingers were obviously meant to be resting gently upon it. He appears to be standing at a window opening. All the separate elements of his costume are the same colour, suggesting that he belongs to a particular group or institution. The most obvious possibility is the University of Leuven, founded in 1425. Though the artist was a native of Haarlem, he settled in Leuven, near Brussels, in the mid-1440s. The fact that Bouts demonstrably knew the university official Jan van Winckele – he acted as witness to Bouts's will in 1475 – raises the possibility that this portrait depicts van Winckele. The hypothesis is all the more appealing because the year 1462 was personally significant to van Winckele, as he was elevated to an important notarial position at the university. His costume may reflect the university's code of dress, which called for plain, respectable attire.

The date 1462 in the background captures our attention, not least because it creates the illusion of being partly carved into the wall, partly projecting out of it. Such effects were typical of van Eyck and his Bruges followers, who prized spatial tricks and illusions, but they were also imitated more widely. Since this curious effect would be very difficult to create on a real wall, it reminds us that the painted image is not an objective copy of reality, but partly a product of the painter's imagination.

16

HANS MEMLING (ACTIVE 1465; DIED 1494)

The Virgin and Child with Saints and Donors (The Donne Triptych)

About 1478
Oil on oak, centre panel 71 × 70.3 cm, side panels each 71 × 30.5 cm
NG 6275

The kneeling patrons in the centre panel are the Welshman Sir John Donne (died 1503) and his wife Elizabeth, Lady Donne, along with an unidentified daughter. Their collars, made up of suns and roses with pendants of enamelled white lions, signify their allegiance to the Yorkist King Edward IV of England. In 1471 Donne fought for the King at the battle of Tewkesbury, one of the decisive battles of the English 'Wars of the Roses', and was knighted on the field. At this period he played an important role in diplomatic relations between England and the Burgundian Netherlands. It must have been on one of his visits to the Netherlands that he commissioned this triptych from Hans Memling, a German painter who settled in Bruges in the mid-1460s and ran a highly successful workshop there. Donne's choice of a renowned Netherlandish painter for the commission signifies that he wished not only to express his piety, but also to advertise his high social status, his connections to the Burgundian court and his refined taste.

The triptych was probably kept at one of Donne's residences, perhaps on an altar in a private chapel where it could have served as a setting for the Catholic Mass as well as a focus for private prayer. Saints John the Baptist and John the Evangelist, on the inner left and right wings respectively, are patron saints of the donor. The saints on the exterior, depicted as stone statues, would have been visible when the triptych was closed. Saint Christopher carrying the Christ Child, in particular, is elegant, complex and animated, appearing to project from the shallow niche and enter the space of the viewer. The significance of such effects has been much debated, but here, at one level, may anticipate the viewer's desire to cross the boundary from one world to another, from the material world to the divine – a transition also represented by the opening of the triptych to reveal a place of colour and light.

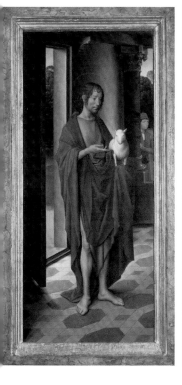
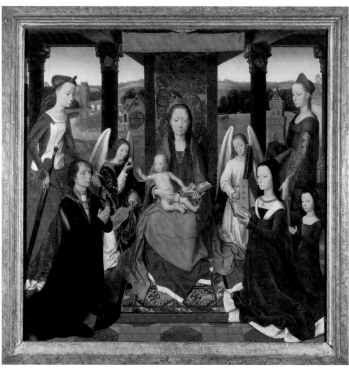
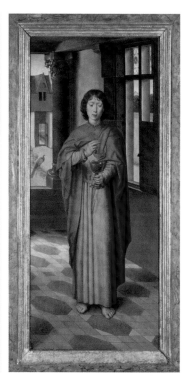

17

HANS MEMLING (ACTIVE 1465; DIED 1494)

Saint John the Baptist and *Saint Lawrence*, two panels from a triptych

About 1480
Oil on oak, left panel 57.5 × 17.3 cm, right panel 57.5 × 17.1 cm
NG 747

These elegant paintings are characteristic of the work of Hans Memling. They were originally the wings of a small-scale triptych (the centre panel, showing the Virgin and Child, is now in the Uffizi, Florence). Such exquisite images of saints holding their attributes are frequent in Memling's oeuvre and must derive from a comprehensive series of drawn patterns kept in his workshop.

On the reverse is a landscape inhabited by nine cranes; in the foreground of the left panel stands the vigilant crane, holding a stone in its upraised claw: according to legend, it stood guard in this manner so that on falling asleep it would drop the stone and immediately awaken. The nine birds are regularly spaced out in the manner of medieval model-book drawings and executed in shades of grey with touches of yellow and bright red, an exercise in courtly refinement and artistic nuance. By introducing an effect of half-light at sunrise, Memling additionally creates a poetic, even mysterious mood that befits the enigmatic nature of the emblem. The decoration of the panels sets up a series of intriguing contrasts between the exterior and interior of the object: between greyness and colour, sunrise and daylight, secular and religious, obscurity and clarity.

The arms on the reverse of the left panel, along with the emblem of the vigilant crane, indicate that the picture was made for Benedetto Pagagnotti (died 1523), who, when the painting was made around 1480, was a friar at the Dominican convent of San Marco in Florence. Pagagnotti had close familial and political ties with the Medici rulers of Florence, however, and his taste for Netherlandish oil painting coincided more closely with the sophisticated outlook of their circle than with the stricter atmosphere of San Marco.

18

HANS MEMLING (ACTIVE 1465; DIED 1494)

A Young Man at Prayer

Mid-1470s
Oil on oak, 39 × 25.4 cm
NG 2594

The man, tightly framed in a neutral space, is engaged in his private devotions. The object of his prayer, probably the Virgin Mary, would have been painted on a companion panel attached to this one with hinges. Memling seems to have had various ideas for the position of the hands, as shown in the underdrawing (see fig. 3, p. 9).

A number of diptychs by Memling were commissioned by young men early in their careers and lives, and probably before their marriages. This sitter may similarly have chosen to record his virtue, piety and social standing at a particular moment in his life. Though he was evidently very wealthy, he chose to portray himself in a medium (oil paint) that was not intrinsically expensive but was suitable for a lifelike and subtle portrait, including convincing representations of his expensive costume and jewellery. Portraiture was a specialism of Memling and his portraits are among the most refined works in his oeuvre. Especially beautiful is the effect of luminosity in the face, seeming to come from a source within rather than outside the figure. The controlled lines of the hair, and their arrangement into refined patterns against the pale flesh, are typical of Memling.

Very few Netherlandish paintings have survived in their original format and with their decoration intact. Many of the pictures that we experience as two-dimensional images on gallery walls were originally intended to be seen from all sides: the diptych of which this portrait was part could be opened, closed and, given its scale, carried around. The frame is original but the original paint layers are lost; these may have included an inscription, device or monogram giving the man's identity.

The general conception of this portrait is close to examples by Rogier van der Weyden. Before his arrival in Bruges in 1465, Memling probably worked in Rogier's Brussels workshop.

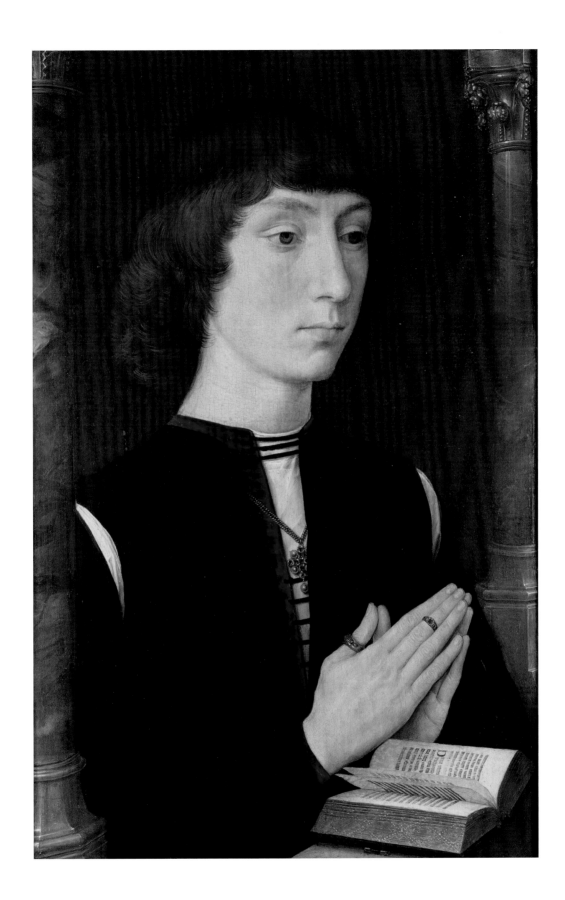

19

GERARD DAVID (ACTIVE 1484; DIED 1523)

Christ nailed to the Cross

About 1481
Oil on oak, 48.4 × 93.9 cm
NG 3067

In order to generate empathy in the observer, the picture depicts a moment of intense suffering in explicit detail. Christ's reddened face suggests his pain; rivulets of blood run down his face and the two men at his feet pull hard on a rope to draw the feet into the position in which they are nailed. The hardness of the tools and weaponry of the soldiers – nails, hammers, sword and spade – underlines the violence of their activities. Christ's chest, distorted, stretched out and flattened, conveys his bodily pain. Gazing directly out, he seems to call on the viewer to respond.

Lying on the ground in the lower left is a blue garment, probably that of Christ for which the soldiers, in their brutality, cast lots. The skull, at which a dog sniffs, identifies the location as Golgotha, called in the New Testament 'the place of the skull'. Connected to this name – and to the idea that Christ, as the 'second Adam', redeemed the sins of mankind through his sacrifice – is the tradition that the skull of the first man, Adam, was buried there.

The small figures in the upper left, just coming into view, are copied (probably via a pattern drawing) from a painting of the Crucifixion made in the 1430s or 1440s by Jan van Eyck or a follower (now Metropolitan Museum of Art, New York). Their out-of-date costumes are fitting here, in a scene set in early Christian antiquity.

Originally the central section of a winged triptych, the picture was probably flanked by two paintings now both in Antwerp: on the left, *Pilate and the Chief Priests*, and on the right, *The Virgin, Saint John the Evangelist and the Three Marys* (both Koninklijk Museum voor Schone Kunsten). Highly unusually for a triptych with a painted interior, these wings appear to have had relief sculpture affixed to the reverses.

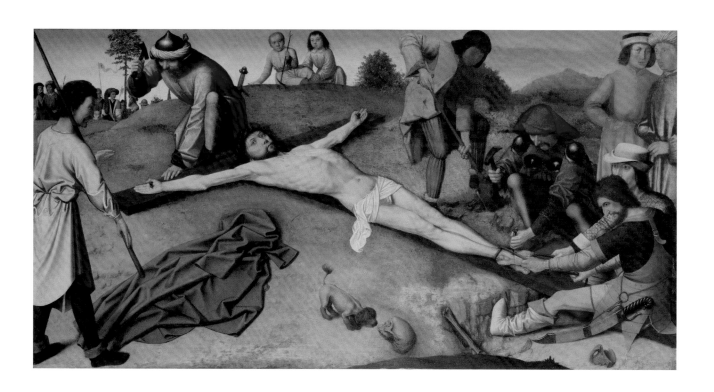

GERARD DAVID (ACTIVE 1484; DIED 1523)

The Virgin and Child with Saints and Donor

Probably 1510
Oil on oak, 105.8 × 144.4 cm
NG 1432

The Virgin and Child are shown with three female saints, from left to right: Saint Catherine of Alexandria, Saint Barbara and Mary Magdalene, as well as the donor, Richard de Visch van der Capelle (died 1511), canon and cantor of the collegiate church of St Donatian in Bruges. The figures have a strongly sculptural and geometrical character, especially pronounced in the Magdalen (whose form incorporates the seat on which she sits). Though each saint occupies her own world, the figures are linked rhythmically by means of their outstretched arms and hands, and their repetitive gestures.

In St Donatian's, the altarpiece stood on the altar of Saint Catherine in the chapel of Saint Anthony and it incorporates both these saints: Saint Catherine re-enacts her mystical marriage with Christ, while Saint Anthony is visible in the mid-ground walkway, wearing black and looking out at us, his hand resting on a fence. In the same walkway, on the left, an angel reaches up to pick a bunch of grapes from the vine, an allusion to the wine of the Eucharist.

The lifelike portrait of the canon, the accurate representation of his costume and the representation of his family's coat of arms on the collar of the little greyhound, would all help future generations to remember him and pray for his soul's salvation. Some viewers would have recognised the cantor's staff lying on the tiled floor, decorated with a silver-gilt image of the Trinity; dating back to the fourteenth century, this staff belonged to St Donatian's church and was presumably used by Richard.

Born in Oudewater in the Northern Netherlands, but in Bruges by 1484, Gerard David joined a line of painters who worked in the tradition of van Eyck. In its symmetry, stillness and attention to detail this painting emulates van Eyck's work of the mid-1430s.

21

GERARD DAVID (ACTIVE 1484; DIED 1523)

Canon Bernardijn Salviati and Three Saints

After 1501
Oil on wood, 103.4 × 94.3 cm
NG 1045

The painting was the left wing of a large-scale diptych permanently installed at an altar in the church of St Donatian in Bruges, where Bernardijn Salviati (died 1519) was a canon. He was the friend and possibly cousin of Richard de Visch van der Capelle (see *The Virgin and Child with Saints and Donor*, plate 20). The top, originally arched, has been cut down; the inner right-hand wing showed a Crucifixion (Staatliche Museen, Berlin). The patron is presented by his name saint, Bernardino of Siena (died 1444), who is accompanied by Saint Martin on the left, and by Saint Donatian. Prayers and masses for the soul of Salviati, as well as for his mother and the souls of all Christians, were performed at the altar. The diptych format was chosen because the altar was set in an awkward and narrow space against the church's choir screen.

The three saints appear like living figures and are highly individualised. In order to differentiate them David must have drawn from models (note the blemish on the cheek of Saint Martin, on the left). Their poses and the angles of their heads are deliberately varied: they are seen in profile (Saint Martin), in three-quarter-view (Saint Bernardino) and almost full-face (Saint Donatian). The beggar in the background alludes to Saint Martin's charitable act of dividing his cloak for a beggar, thus serving as a type of attribute. The emphasis on small-scale handling (seen in the tiny stitches of black embroidery at the shoulders of Salviati's costume) is typical of David's painting of this period.

The reverse, now severely damaged, is decorated with a *trompe l'œil* window at which the figure of the resurrected Christ appears. When the diptych was closed, this figure would have been seen and venerated; it also served to confirm the divinity of the human Christ represented crucified on the Cross on the interior.

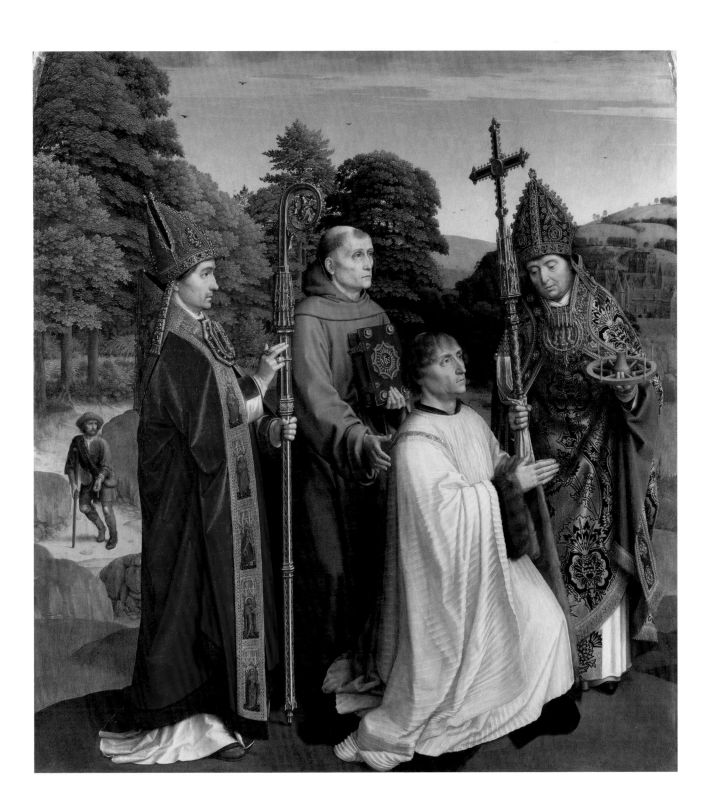

JUSTUS OF GHENT (ACTIVE ABOUT 1460–1480) AND WORKSHOP

Music

Probably 1470s
Oil on poplar, 156.3 × 97.4 cm
NG 756

Shown from a low viewpoint, the young man kneels in homage before an allegorical figure of Music; her attribute, the portative organ, is placed on the lowest step. Music is one of the Seven Liberal Arts, branches of secular knowledge central to the university curriculum of the Middle Ages. The group was subdivided into the *trivium* (Grammar, Logic and Rhetoric) and the *quadrivium* (Geometry, Arithmetic, Astronomy and Music).

The picture was made for Federico da Montefeltro (1422–1482), Duke of Urbino, who was both the foremost *condottiere* (captain of mercenary soldiers) of the day and a model of the ideal Renaissance prince. According to Federico's biographer, 'because he could not find in Italy painters in oil to suit his taste he sent to Flanders, and brought thence a master who did at Urbino many very stately pictures …' This was probably Justus of Ghent, who was working in Urbino by 1473.

Music has been cut from a very large and heavy panel which showed more than one of the Liberal Arts. These panels were affixed to the topmost section of the walls of the room, creating the illusion that the architectural setting was a continuous part of the real space: this made oil, with its capacity for perfect illusionism, the medium of choice. It is not known for which room, or for which of Federico's palaces, the pictures were painted, but the subject suggests a place of study and contemplation, such as a *studiolo* or a library.

The most noticeable feature of the handling is the play of light and shade, in which deep, transparent shadows enliven the spaces around and between the figures. The breadth of handling and tactility of the figures may be explained in part by the distance from which they would be seen. The technique is deeply embedded in Netherlandish tradition yet is relatively fast and economical, perhaps because the schedule was pressing.

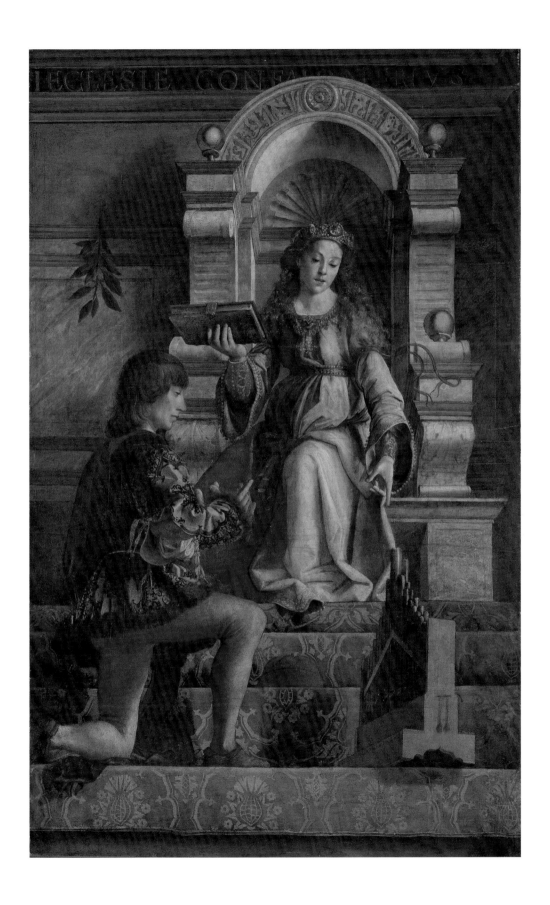

FOLLOWER OF HUGO VAN DER GOES

Virgin and Child

About 1485
Oil on oak, 32.3 × 21.4 cm
NG 3066

The image of the Virgin and Child is based on a design, probably quite broadly rendered, by Hugo van der Goes, one of the most innovative and technically brilliant painters in the Netherlandish tradition. A master in the Ghent guild of painters from 1467, he removed himself from the world in the mid-1470s to be professed as a *frater conversus* (lay brother) at the Augustinian monastery of the Rode Klooster near Brussels. Another member of the community, Gaspar Ofhuys, has left us an account of an attack of madness suffered by Hugo towards the end of his life; he died in 1482.

The Virgin and infant Christ appear tightly framed against solid black. Rather than appearing in our world, as in Dirk Bouts's *Virgin and Child* (plate 13), they inhabit an abstract realm. The close-up format, however, and the caring gestures of the Virgin, who envelops her child in the grey fur of her robe, allow for a sense of intimacy with the viewer. The child plays with a string of prayer beads, made of coral and glass, a reference to the common practice of fingering such beads one by one as prayers were recited, in order not to lose count. The painting evokes the tactility of this practice.

The framed centre panel has been encased inside another old frame, dating from around 1500, to which are attached wings inscribed with a prayer; this was probably done by a nineteenth-century dealer. The prayer is known as the *Ave Sanctissima* from its opening words ('Hail, most holy Mary …') and was associated with a type of the Virgin called the *Virgo in Sole*, in which the holy figures are surrounded by the rays of the sun. Notably, it contains a reference to the doctrine of the Immaculate Conception, which held that the Virgin herself was born without original sin.

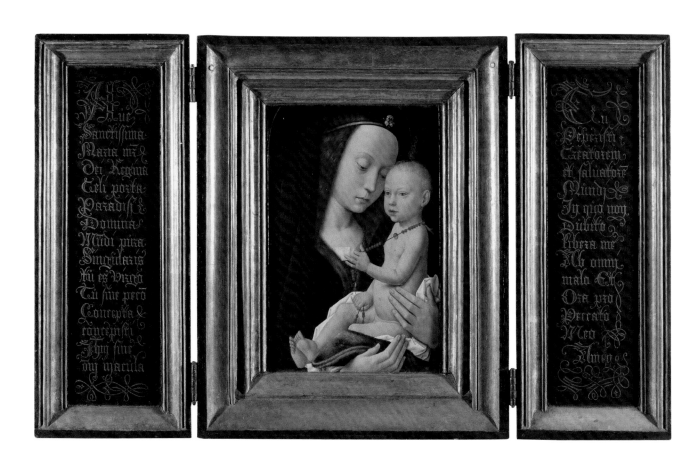

24

GEERTGEN TOT SINT JANS
(ABOUT 1455/65–ABOUT 1485/95)

The Nativity at Night

Possibly about 1490
Oil on oak, 34 × 25.3 cm
NG 4081

The Gospel of Luke recounts that the Virgin laid the infant Christ in a manger and that an angel of the Lord appeared to some shepherds watching their flocks by night, 'and the glory of God shone around them and they feared exceedingly' (Luke 2: 7–9). This depiction of these events was designed to touch the heart of the viewer, as indicated by the gesture of Saint Joseph on the right. The Virgin and angels adore the small, helpless child, lying in his crib. An atmosphere of hushed silence and intimacy is created by the sense of a pocket of light in the darkness, in which the figures gather in wonder and awe. In this devotional context, the divine light of the Christ Child can be understood as a source of grace.

To illuminate the nocturnal scene Geertgen has used various carefully differentiated light sources, both man-made and divine: the light of the fire, of the angel and of Christ. The way in which the light emanating from the infant illuminates the faces of the foreground characters from below, and to varying degrees, seems to indicate direct observation of nature, although Geertgen in fact derived the idea from a now-lost *Nativity at Night*, probably by Hugo van der Goes, painted in the 1470s. The effect makes the scene remarkably believable and memorable.

Used for private devotion, the design seems to leave a space for the spectator in the centre foreground, inviting him or her to draw closer into the world of the painting. It has been cut down considerably at the lower edge, however, and at the top and right-hand edges, which makes the close-up format slightly misleading.

Geertgen tot Sint Jans, active as a painter by the 1480s, lived at the convent of St John of the Knights Hospitallers in Haarlem. His name 'tot Sint Jans' means 'at Saint John's'.

MASTER OF THE VIEW OF ST GUDULA
(ACTIVE LATER FIFTEENTH CENTURY)

Portrait of a Young Man

Probably early 1480s
Oil on oak, 22.8 × 14 cm
NG 2612

From the man's gaze to the left and display of what is probably a prayer book (which, like surviving examples, opens to form a heart shape), we can infer that the portrait was the right-hand panel of a small devotional diptych. The artist makes the figure seem close to us by his use of dark, saturated colours applied with a precise graphic technique that serves to emphasise the details of his face, clothing and outline. He does the opposite with the background, depicting it with broader handling and lighter, more muted colours. The figure's presentation as if at a window reinforces the picture's intimacy.

The Master of the View of St Gudula ran a productive workshop in Brussels in the 1470s and 1480s. He seems to have created a market niche for pictures with views of Brussels; indeed, he is named after a picture that shows the collegiate church of St Gudula, the town's principal church. In the present portrait the view includes Our Lady of the Zavel (Notre-Dame du Sablon) in Brussels, the cemetery beyond the church and the fourteenth-century town walls. The picture is thus an early example in Netherlandish painting of the depiction of a recognisable locality, if not with exact, topographical accuracy.

The artist has applied the oil paint in a lively, direct manner, as well as adopting shorthand conventions for the depiction of such oft-repeated objects as foliage and grass. Such conventions could be taught and handed down from master to apprentice. Notable, too, is the use of real gold in the image, which, attracting the eye with its gleaming quality, was used for the small, round cap badge and the edges of the pages of the book. The surfaces were then modelled with oil glazes. These small notes of gold must have been echoed and balanced by the original frame, which was gilded.

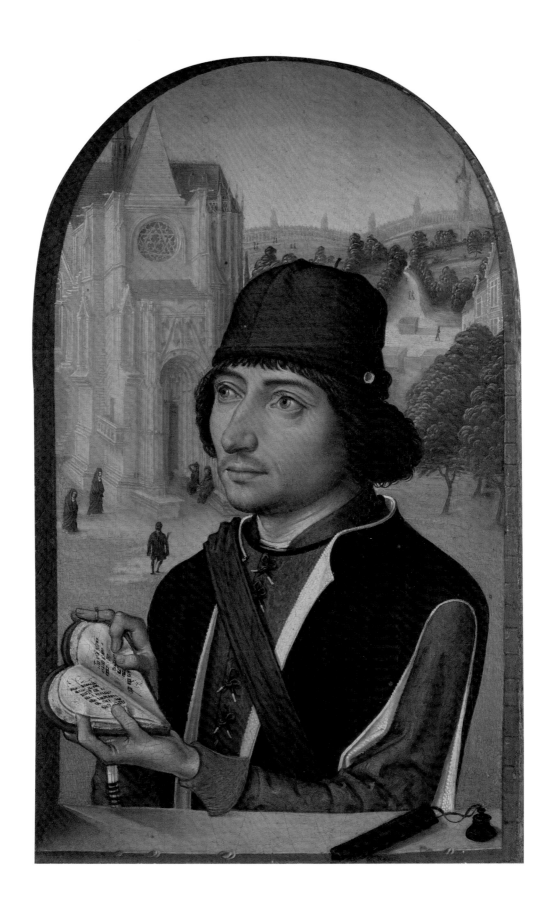

HIERONYMUS BOSCH (LIVING 1474; DIED 1516)

Christ Mocked (The Crowning with Thorns)

About 1490–1500
Oil on oak, 73.5 × 59.1 cm
NG 4744

Christ's persecutors, identified by their costumes as brutes and non-believers, are poised to begin their task. One of the tormentors is about to tear off Christ's robe, while another prepares to force the crown of thorns on his head: momentarily, it takes on the position of a halo, indicating the divinity of the man standing before us. The type of spiked collar worn by the man in the upper right reappears on a snarling dog in the *Haywain Triptych* (figs 11 and 12, p. 19), suggesting that he is ready to attack. Yet not one blow has been struck. In this picture, the emphasis is not on the historical narrative but on Christ's direct dialogue with the devout viewer, meditating on the suffering that mankind has inflicted – and which he continues to inflict – upon Christ.

Over the course of the fifteenth and sixteenth centuries the techniques of Netherlandish oil painting became increasingly economical and direct. A special role within this development was played by Bosch, who seems to have appreciated the textural qualities of the oil paint itself, allowing the fluent, lively way he worked the paint to remain visible. We can see quite clearly that the pointy beard of the man at lower left was created by dragging on fairly dry white paint with a stiff brush. Though it has become more transparent over time, making the liquid under-drawing visible to the naked eye, Christ's robe must always have been painted thinly.

Bosch was one of the most inventive painters of the period. His workshop in 's-Hertogenbosch produced many pictures in his style, making it difficult to identify the hand of Bosch himself. Even signatures are not helpful in this respect: though his name is inscribed on the *Haywain Triptych* in the Prado, for example, it is unlikely that he painted it. *Christ Mocked*, however, is generally accepted as a work by Bosch.

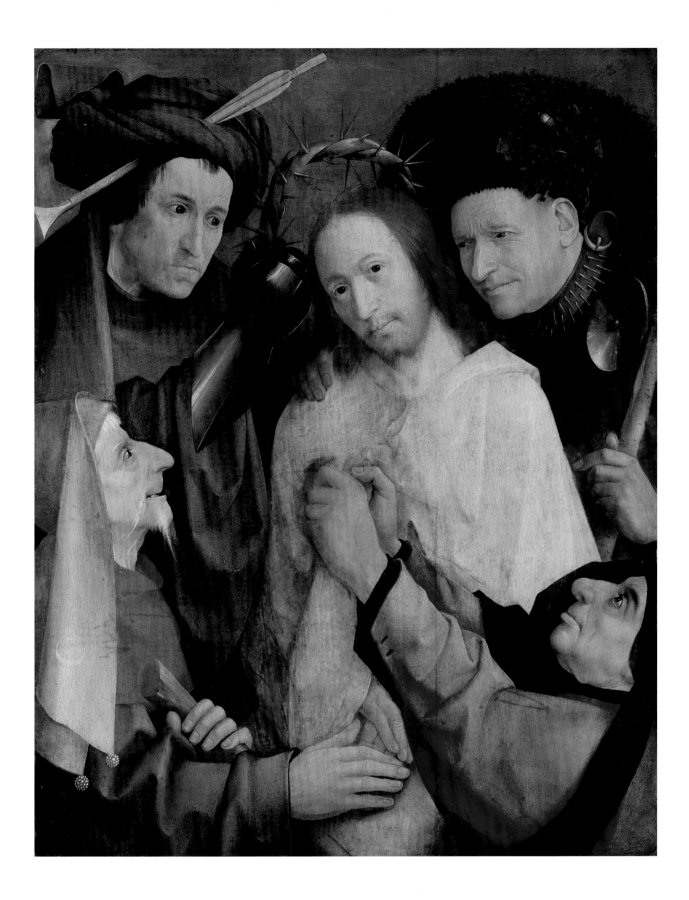

JUAN DE FLANDES (ACTIVE FROM 1496; DIED 1519)

Christ appearing to the Virgin with the Redeemed of the Old Testament

About 1499–1500
Oil on oak, 21.2 × 15.4 cm
NG 1280

Following his Resurrection, Christ descended to hell to liberate the righteous souls there, including, shown here behind him, Adam and Eve. He appears at the threshold of the Virgin's chamber and announces the Resurrection to her.

In keeping with its joyous subject matter, the painting is clear and light. The colours are pale and high-keyed and the handling is exquisite, the paint being applied thinly and with exceptional care and delicacy. This is one of a series of no fewer than 47 little pictures, all the same size, telling the narrative of Christ's redemption of mankind, beginning with the Annunciation to the Virgin and ending with the Last Judgement. A number of these were praised by the great German master Albrecht Dürer as '… forty small panels painted in oil colours the like of which for precision and excellence I have never seen'.

The series was commissioned by Isabella of Castile for private prayer. The paintings would have been an aid to her goal of participating in the events of Christ's life by visualising them mentally: the scrolls, unusually prominent here, express the words and feelings of the characters. After Isabella's death in 1504 the series is described as being stored in an 'armario' or cupboard, suggesting that, rather than being framed in a single ensemble, they could be used flexibly either singly, in pairs or in groups. Isabella could use the pictures to personalise her devotional experience, choosing to meditate on particular events, themes and narrative sequences.

The design makes clear visual sense of a highly complex subject, one that is difficult to imagine, making it an effective devotional aid. In particular, the painter was able to suggest that a vast multitude of souls appear behind Christ by imitating the effect of aerial perspective in nature. The conception is notably clear and emotive – and Isabella surely appreciated her painter's skill in this regard.

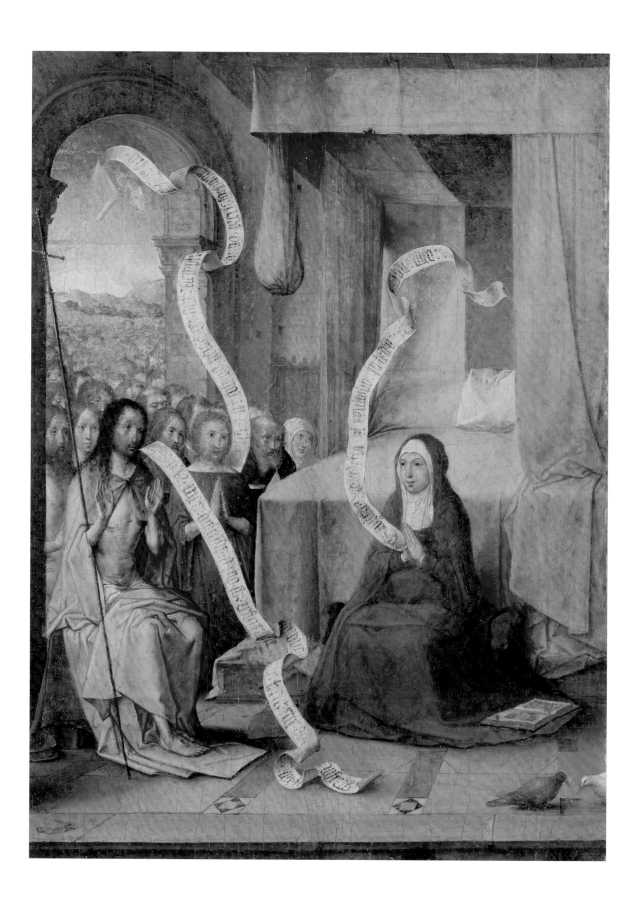

MASTER OF DELFT

Scenes from the Passion of Christ

About 1510
Oil with some egg tempera on oak, central panel (*The Crucifixion*) 98.2 × 105 cm, left panel
(*Christ presented to the People*) 102.2 × 49.3 cm, right panel (*The Deposition*) 102 × 49.4 cm
NG 2922

Kneeling at lower left in the centre panel is the patron, wearing the habit of a Premonstratensian canon. He was probably provost of the convent of Konigsveld, near Delft (there is a depiction of the tower of the New Church in Delft in the centre panel) and was thus charged with the pastoral care of the nuns. The altarpiece was probably installed on the high altar of the convent church. (Altarpieces were the setting for the Mass, which came to a highpoint with the mysterious transformation of the Host into the body of Christ, a mystery known as the transubstantiation.)

Extensive narrative sequences were increasingly common during this period. Here, somewhat unexpectedly, the narrative begins in the upper right of the centre panel, where Christ prays to God the Father at the Agony in the Garden, and Judas arrives to arrest him; it then picks up in the left wing with the *Ecce Homo* ('Behold the Man', where Pilate presents Christ to the chief priests) before moving to the background of the left wing, where the two thieves await Christ before starting on the road to Calvary. The road reappears in the mid-ground of the centre panel, where Christ is shown carrying the Cross, and the narrative culminates in the foreground Crucifixion.

The altarpiece was designed to be seen from a relatively low viewpoint. The closed wings present fictive statues of the Virgin and Child, Saint Augustine of Hippo, Saint Peter and Saint Mary Magdalene, standing in niches. As the wings were opened, this monochrome imagery would give way to the full colour of the interior, where Christ's body appears on high as an object of veneration. Rather than appearing static and inert, the fictive statues on the reverse are animated and appear to communicate with each other; they seem to foreshadow the movement and energy of the narrative scenes within.

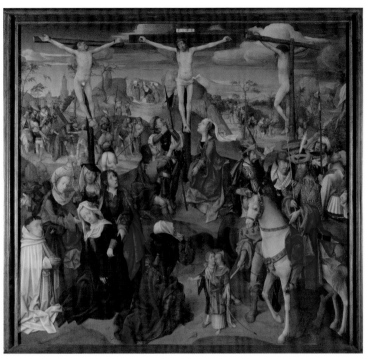
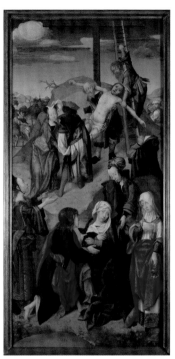
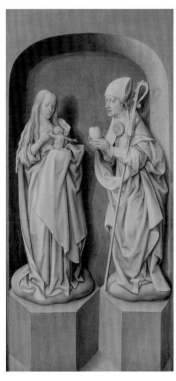
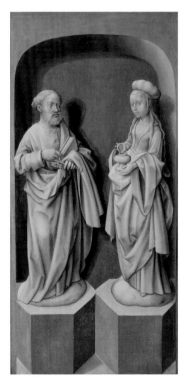

29

MASTER OF THE BRUGES PASSION SCENES

Christ presented to the People

About 1510
Oil on oak, 93.4 × 41.5 cm
NG 1087

According to the Gospel of John, Pontius Pilate, finding no guilt in Jesus, brought him outside to show him to the chief priests and their attendants, saying 'Behold, the man!' When they saw him, they cried out 'Crucify him! Crucify him!' (John 19: 4–6). This painting was probably the inner left wing of an altarpiece, painted around 1510.

The compositional framework and some of the figures and poses derive from a range of images by other artists. An engraving of the *Ecce Homo* by the German painter and engraver Martin Schongauer (died 1491) supplied the figures of Christ and Pilate in the foreground. Schongauer's series of prints of the Passion of Christ were a rich resource for painters at this period, when narrative complexity was increasingly in demand. Hans Memling's *Passion of Christ* of around 1470 (Galleria Sabauda, Turin), a masterpiece of simultaneous narrative, provided the small-scale scenes of the Flagellation and Mocking of Christ depicted in the mid-ground. The source for the mythological scene represented on the narrow frieze of the architecture above, which seems to represent a battle of the sea gods, must have been a drawing or print imported from Italy, perhaps even the famous engraving of the subject by Andrea Mantegna (about 1430/1 – 1506).

This painter thus drew on a rich collection of models preserved in his workshop, consisting of prints, drawings, and also perhaps, paintings. Such collections of models, known as 'patrons' or patterns, were a vital part of a master painter's equipment and, along with other tools of his craft, were carefully preserved and handed down from the master to his son or successor. They typically included drawings of heads, hands and figures, landscape and ornamental motifs and copies of works by other artists. Compositional models, from which clients could choose, were also preserved in the workshop (see the *Pietà* from the workshop of Rogier van der Weyden, plate 10).

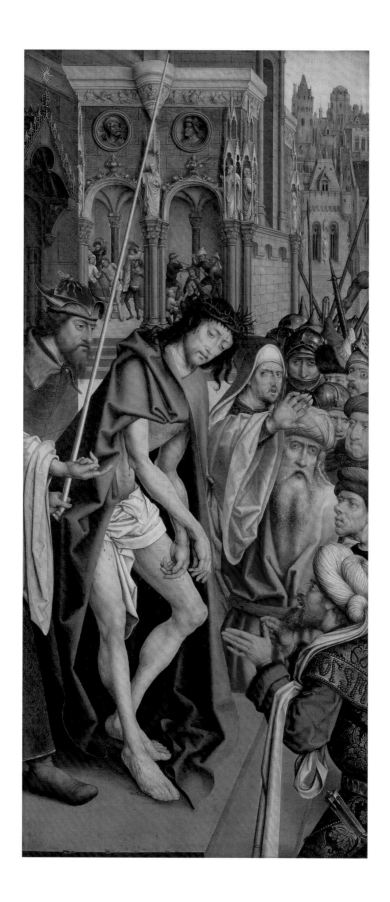

NETHERLANDISH

The Virgin and Child enthroned

About 1520
Oil on oak, 22.9 × 14.6 cm
NG 3045

A large area of the surface of this panel is given over to the elaboration of the canopy above the Virgin's throne, which overshadows the small-scale figures below. This reflects the fashion for intricate ornamentation in the early sixteenth century, which encompassed works in a range of media. In this painting the stone structure of the canopy is divided and subdivided into multiple curvilinear compartments to create a visually complex structure. When inventing such designs, painters were able to give free rein to their fantasy: the giant acanthus leaves which curl freely in space above the Virgin's head would not be placed there in a real structure, as they would be too heavy. The painting technique is distinctly graphic, the main details of the architecture being delineated in black and white lines on top of a thin layer of grey paint, using the point of the brush. Such a technique places the picture firmly in the early sixteenth century.

Central to the significance of the image, depicted on a small scale and in delicate, flickering brushstrokes, are the figures of the Virgin Mary and the infant Christ. Spreading out his arms to either side, Christ adopts a pose which prefigures his eventual position nailed to the cross. He holds a thin gold cross in his left hand and a tiny black scourge in his right, both instruments of the Passion, through which he triumphed over the devil. The landscape is rendered with green trees and bushes in the mid-ground and blue hills in the background, where a range of tall, jagged mountains rises abruptly from the hillside. Though this fantastic mountain range is broadly reminiscent of the 'world landscapes' painted by Joachim Patinir in Antwerp, the feature is found in landscapes made elsewhere in the Netherlands.

QUINTEN MASSYS (1465–1530)
The Virgin and Child enthroned, with Four Angels

About 1495
Oil on oak, 62.2 × 43.2 cm
NG 6282

Massys registered with the Antwerp guild of painters in 1491, becoming one of the leading painters in the city. The Virgin and Child enthroned, with Four Angels was probably painted around 1495, early in his Antwerp career. The Virgin's golden throne and the angels holding the crown over her head identify her as Queen of Heaven. Typical of Massys, the painting is an inventive reworking of traditional images. The depiction of the Virgin enthroned at the head of a luxurious carpet goes back to Jan van Eyck, perhaps via one of his Bruges successors such as Hans Memling or Gerard David. The music-playing angels posed on either side of the throne, on the other hand, are taken from a much-copied Virgin in an Apse attributed to Robert Campin, the original of which is now lost.

The variety of techniques and materials employed, along with the innovative colour scheme, lend the painting considerable visual interest. While the architectural setting and throne are delineated lucidly and sharply, the figure of the Virgin and the fluffy hair of the angels are softly painted. The gold of the throne – which is real gold – is overlaid with a network of painted lines, both hatched and cross-hatched, to produce an effect of three-dimensionality. Different strokes again are used to represent the woolly texture of the carpet, represented with little dots and dashes of the brush.

Gold was used in a wide variety of ways in Netherlandish painting. It was not van Eyck's typical practice to use gold in the pictorial field, but the original frame of his Portrait of a Man (Self Portrait?) (plate 2) is decorated with gold leaf. Gold was also applied to the background of certain paintings, as well as serving to provide accents within an image (see Dirk Bouts, Christ crowned with Thorns, plate 14, and the Master of the View of St Gudula, Portrait of a Young Man, plate 25).

QUINTEN MASSYS (1465–1530)

An Old Woman ('The Ugly Duchess')

About 1513
Oil on oak, 62.4 × 45.5 cm
NG 5769

This grotesque old woman is being held up as an object of ridicule. She wears a bizarre double-horned headdress, to which a hefty gold brooch is attached. Affixed to it is a veil with a pleated edge, which, rather overblown, only adds to the absurdity of the ensemble. The low-cut dress, which might be appropriate for a younger woman, exposes her flabby, withered breasts. She is all the more ludicrous because her costume is outmoded: the style of the horned headdress, for example, dates back to the early fifteenth century. This archaic costume makes her appear outlandish, but may also have been meant, comically, to underscore her great age.

The man in the companion portrait of *An Old Man* (private collection, USA) also wears old-fashioned costume. The woman is offering the rosebud to him. Ironically, the flower, so fresh that it is still unopened, is positioned between the woman's unsightly breasts. Her attribute of the rose, along with her revealing costume, identify her with Luxuria, the personification of lust. In his *Praise of Folly* (1512) the humanist scholar and writer Erasmus of Rotterdam castigated old women for falling prey to lust. His ideas would have been well known to Massys, who had connections to humanist circles and in 1517 painted a portrait diptych of Erasmus and the scholar Pieter Gillis.

As Massys is known to have copied drawings of 'grotesque heads' by Leonardo da Vinci, using them to create expressive figures, it is often assumed that he based this satirical image on such a drawing, now lost to us. Another, more recent, proposition is that the painting relies on a life study by Massys. The woman's facial deformities suggest that she suffered from Paget's disease, which causes irregular bone formations. If this is a portrait of a real person, however, she was not portrayed for her own sake, but rather for the painter's interest.

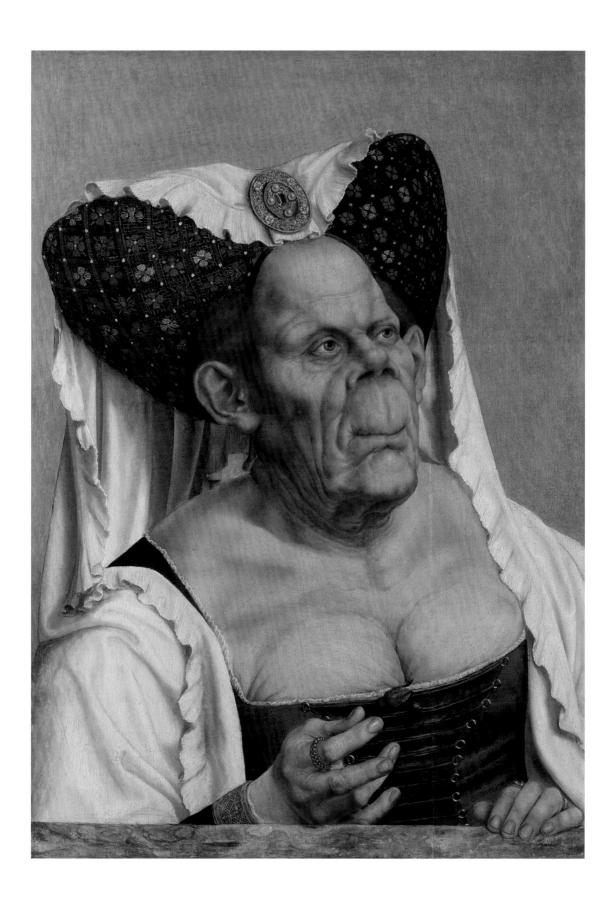

QUINTEN MASSYS (1465–1530)

The Virgin and Child with Saints Barbara and Catherine

Probably about 1515–25
Glue-size on linen, 92.7 × 110 cm
NG 3664

Paintings combining the Virgin Mary with Saint Barbara and Saint Catherine of Alexandria were popular in the early sixteenth century. These two were among the most important of a wider group of 14 auxiliary saints, or 'holy helpers', who were believed to have special powers of intercession before God. In a reference to a vision of Saint Catherine, in which she was mystically married to Christ, the infant Christ pushes himself up onto his feet and leans forward to place a ring on her finger. The two female saints are identified by their attributes positioned behind them: the broken wheel refers to an instrument made for the torture of Saint Catherine (which was miraculously destroyed before it could be put to use) and the small tower to the imprisonment of Saint Barbara by her pagan father. The bulky, three-dimensional softness of the Virgin's form is typical of Massys.

Like Dirk Bouts's *Entombment* (plate 12), the painting is a rare surviving example of a glue-size painting on cloth. Painters used particular techniques when working in this medium, which was not as flexible as oil. It is difficult to create effects of deep, glowing shadow in glue-size painting, for example, because the tonal range (from light to dark) is somewhat limited and the pigments appear relatively opaque. Here, in the skirt of Saint Catherine's costume, at lower left, Massys painted an underlayer in dark blue and then used a brighter blue at a second stage to create the effect of lighter, vertical folds in the material. Working from dark to light in this way is the opposite of oil painting, in which dark shadows are built up gradually in glazes.

Despite the picture's severely damaged condition, subtle effects of light and texture are evident. The seed pearls of Saint Catherine's headgear have sharp, bright highlights while the larger pearls of her necklace were given broader, duller highlights.

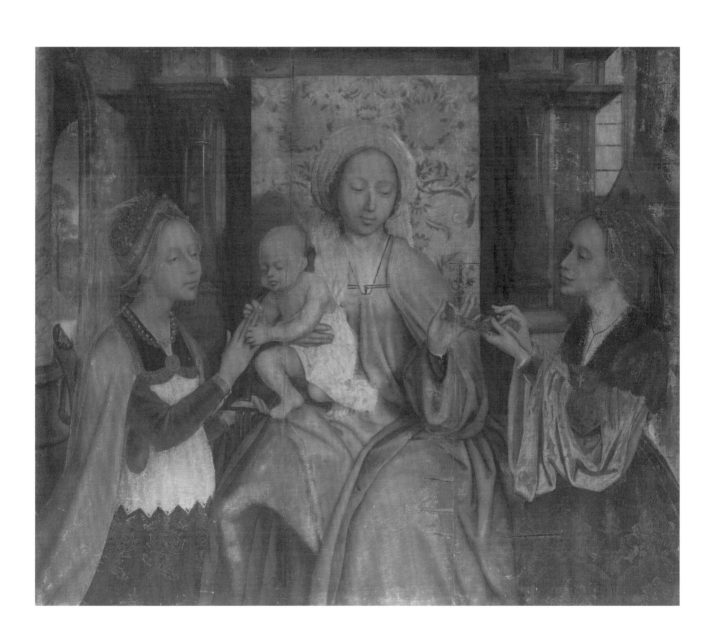

34

JAN GOSSAERT (ACTIVE 1503; DIED 1532)

The Adoration of the Kings

1510–15
Oil on wood, 177.2 × 161.3 cm
NG 2790

One of Gossaert's early works and one of his largest, *The Adoration of the Kings* provides a spectacle of exoticism and wealth. In the centre the Christ Child takes a gold coin from the vessel of gold presented to him by Caspar, the oldest king.

The subject of the Adoration of the Magi held enormous potential for painters to demonstrate a wide range of their skills, and this idea seems to have inspired Gossaert. As a large-scale, multi-figure composition destined for an altar, this example offered the opportunity to demonstrate his prowess in various aspects of painting, such as rendering texture, grouping figures within an architectural structure and creating a sense of deep space. An abundance of objects, animals and fabrics, decorated in a wide array of colours, are all rendered with extraordinary meticulous-ness, down to the tiniest and most intricate ornamental details. The juxtaposition of subtly different colours of blue in the costume of the Virgin and the geometrical rigour of her figure indicate that Gossaert was emulating his older contemporary, Gerard David. So deep is the pictorial space, so profuse the detailing and so rich and varied the colours that Gossaert seems to have been trying to push his powers of invention and artistry to their limits.

The painting was probably the altarpiece for the Chapel of Our Lady in the abbey church of St Adrian at Geraardsbergen, near Brussels. The patron was possibly Daniel van Boechout (died about 1526), Lord of Boelare, who arranged to be buried in the chapel. Gossaert's double signature in this altarpiece – his name is inscribed on the hat of the black king and once more on the collar of his attendant – may have been intended not only to denote his authorship, but also to associate him with the king as a devout giver of a gift to Christ.

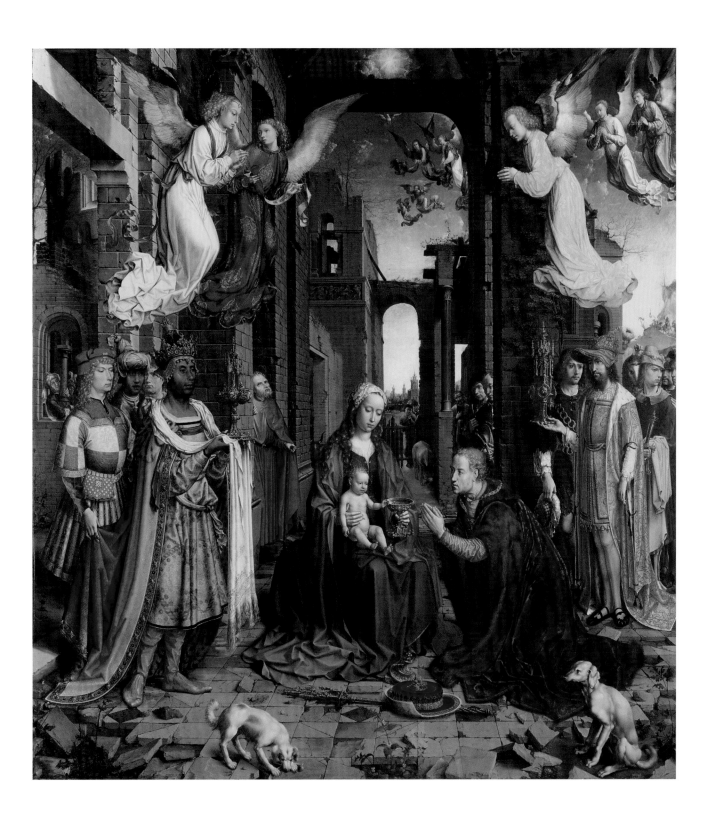

JAN GOSSAERT (ACTIVE 1503; DIED 1532)

A Man holding a Glove

About 1530–2
Oil on oak, 24.4 × 16.8 cm
NG 946

The man is shown seated at a table in three-quarter view, his eyes turned towards us, the near eye being close to the central vertical axis of the composition. The scale of the portrait is very small – unusually so, in fact. It concentrates not only on providing a likeness but also on the outfit and attributes of the sitter which, as in many other portraits of this period, communicate wealth and high social status. The man wears an expensive costume incorporating different types of fur and velvet; most notably, his pinkish gown with black velvet bands around the sleeves has a very wide collar lined with fine, grey-brown fur. He wears two gold rings on his right index finger, one with a blue and the other with a red stone, and he holds a glove. Patrons of the nobility and royalty of the sixteenth century were sometimes depicted holding a single glove as an accessory, which suggests that it conveyed a sense of rank and status. This glove is expensive, being made from soft leather, and, following the custom of the period, may have been perfumed.

The unusually small scale of the portrait has given rise to the suggestion that it was painted for a patron in a hurry, and that he chose a small-scale format to save time. It is, of course, extremely rare to know the precise circumstances surrounding the creation of a given portrait at this period.

The picture falls into the late period of Gossaert's career. After the death of his principal patron, Philip of Burgundy, in 1524, Gossaert was employed by Adolf of Burgundy, Lord of Beveren (died 1540). However, he continued to receive commissions from other prominent patrons and art collectors of the Burgundian–Habsburg Netherlands, including the man portrayed here.

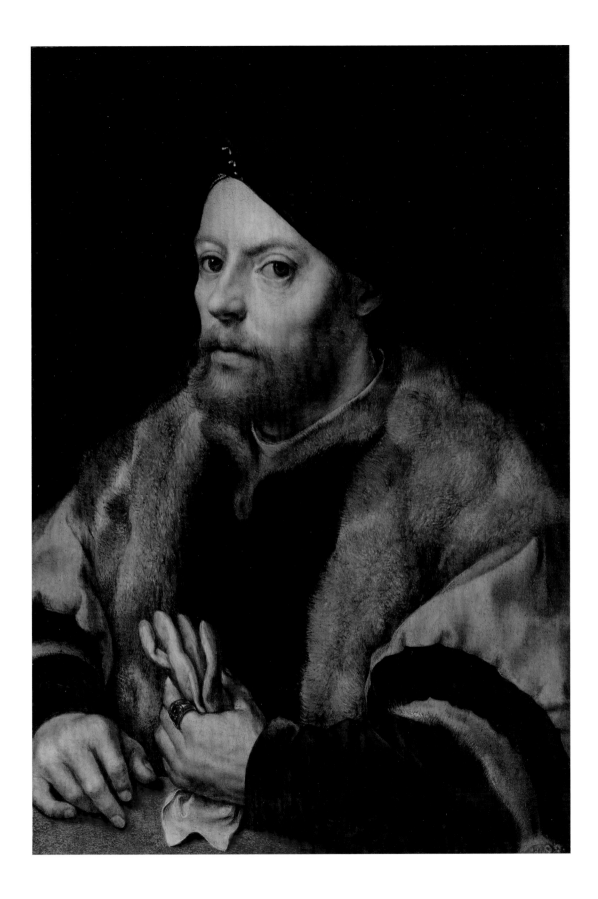

36

JAN GOSSAERT (ACTIVE 1503; DIED 1532)

An Elderly Couple

About 1520
Oil on parchment laid down on canvas, 46 × 66.9 cm
NG 1689

Double portraits within a single pictorial field, like this one, were not as common as paired portraits such as *A Man* and *A Woman* by Robert Campin (plates 4 and 5). In Gossaert's painting the heads of the sitters are large in relation to their bodies, making it possible for the viewer to see the details of the faces closely. This characteristic is essential in all Gossaert's portraits, but perhaps especially in this one, in which the detailing is the main focus of the viewer's interest and admiration. His choice of parchment for the support (the surface on which the image is painted) may mean that he intended to include passages of virtuoso detailing, since parchment provides a suitably fine and smooth surface for detail work.

In the man's portrait it is the silvery stubble on his chin, the soft fur of his cloak and the strained sinews of his scraggy neck which engage us. In a manner typical of Gossaert, the flat ribbons of his cap are shown twisting in space and intertwined with each other, producing a linear pattern in three dimensions – as well as demonstrating Gossaert's ability to represent different tones of black. The portrait of the woman, by contrast, is an exercise in the rendition of light and shadow in which the translucency of her crisp white veil plays an important role.

The badge on the man's hat shows a nude couple with a cornucopia, probably the gods Mercury and Fortuna who governed trade and prosperity. They may indicate that the man was a merchant, but, in contrast to the ageing couple, they also reinforce the theme of the transience of life. There is no hint of interaction between the figures, who gaze in different directions. He appears extroverted; she, introverted – but we are left to extrapolate our own stories from the image, and these, inevitably, will be subjective.

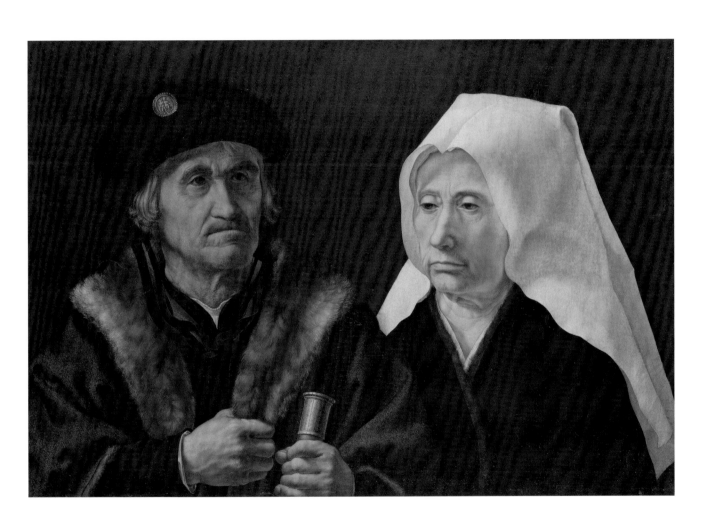

FOLLOWER OF JAN GOSSAERT

The Magdalen

Early sixteenth century
Oil on oak, 29.2 × 22.2 cm
NG 2163

The jar of ointment suggests that the figure is Saint Mary Magdalene. Her attribute of the jar derives from the belief, traditional in Western Europe, that the penitent prostitute who anointed Christ's feet, as described in Saint Luke's Gospel, was the Magdalen (Luke 7: 36–50).

The saint's expensive cloth-of-gold robe and elaborate jewellery, including a pendant set with large sapphires and rubies, is in keeping with the legend that she was descended from royal blood and that, in her early life, she gave herself over to sensual pleasures. The ointment jar she carries – positioned close to the spectator – is decorated with embossed figures in the classical style, including an image of the pagan god Mercury, carrying his caduceus and wearing his winged helmet. This imagery from ancient Roman art, along with the picture's emphasis on material splendour, suggests that, above its importance as an image of a saint, the painting was made to appeal to a well-read client with a taste for the antique, who would appreciate the picture's complexity and ornamental value. Indeed, by the early sixteenth century such paintings were designed to move between the sacred and secular worlds – this only increased their appeal. The picture's stylistic link to the work of Jan Gossaert is reinforced by its association with classical antiquity.

The large number of paintings representing Mary Magdalene suggests that there was a surge in the saint's popularity in the early sixteenth century, culminating in the 1520s. This may have been a reaction in part to the fact that between 1517 and 1520 the French humanist Jacques Lefèvre d'Etaples (died 1536) wrote a series of tracts making the case that the saint's identity had been constructed from references to three distinct biblical figures.

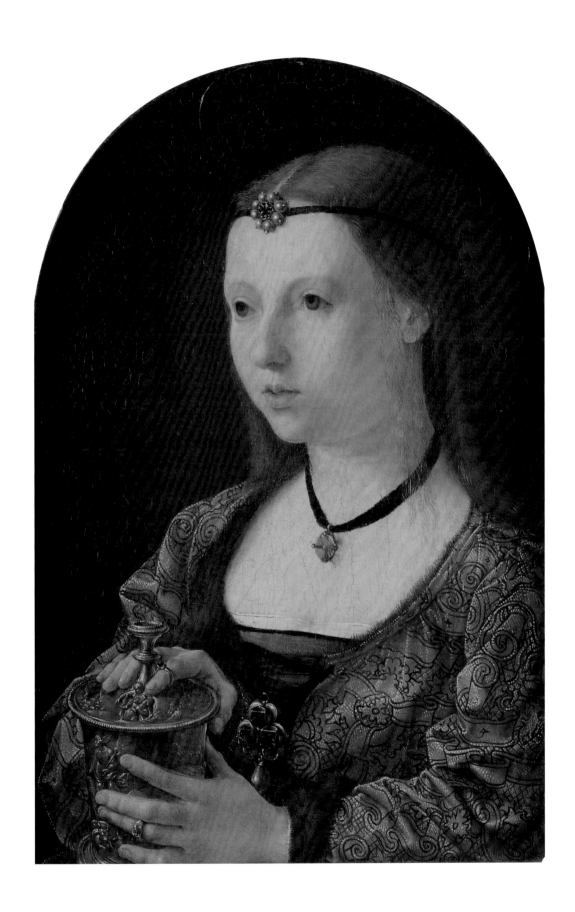

JAN GOSSAERT (ACTIVE 1503; DIED 1532)

A Young Princess (Dorothea of Denmark?)

About 1530
Oil on oak, 38.1 × 28.9 cm
NG 2211

Wearing a serious expression, the girl indicates a particular point on an armillary sphere (a celestial globe in skeletal form) held upside down. Copenhagen is very close in latitude to the point indicated on the sphere, suggesting that she is Dorothea of Denmark (died 1580), one of the daughters of Christian II, King of Denmark. Having been expelled from that country in 1523, Christian, brother-in-law of the Habsburg Emperor, Charles V, left his children in the Burgundian Netherlands, in the care of Margaret of Austria.

The inversion of the sphere is perhaps a metaphor for the overturning of the political and familial worlds of Christian II and his family. Along one of the rings there is a row of letters, with the vowels and consonants grouped separately – perhaps an anagram of the painter's name. Such visual puzzles and devices held great appeal for Gossaert and his noble patrons.

The tight delineation of the gold necklace and myriad pearls of the girl's costume contrast with the softer treatment of her slightly frizzy hair and youthful, plump flesh. Gossaert extends the visual theme of interlocking rings and circles (the Latin *armilla* means bracelet or hoop) to the decoration of her dress. These patterns were originally purple, but the fading of the red lake component of the paint means that they now look blue, both in the dress and cap.

Dorothea is barely turned into three-quarter view, her face shown almost frontally. Gossaert plays with the viewer's perceptions of space by making the figure appear to overlap the fictive stone frame behind her. He conceived the figure as a distinct, three-dimensional form, making it project outwards towards the viewer through a combination of crisp, clear outlines and smoothly modelled forms. The effect reminds us of his long-standing sculptural interests, shown in some of the drawings surviving from his trip to Rome (see pp. 33–4, fig. 20).

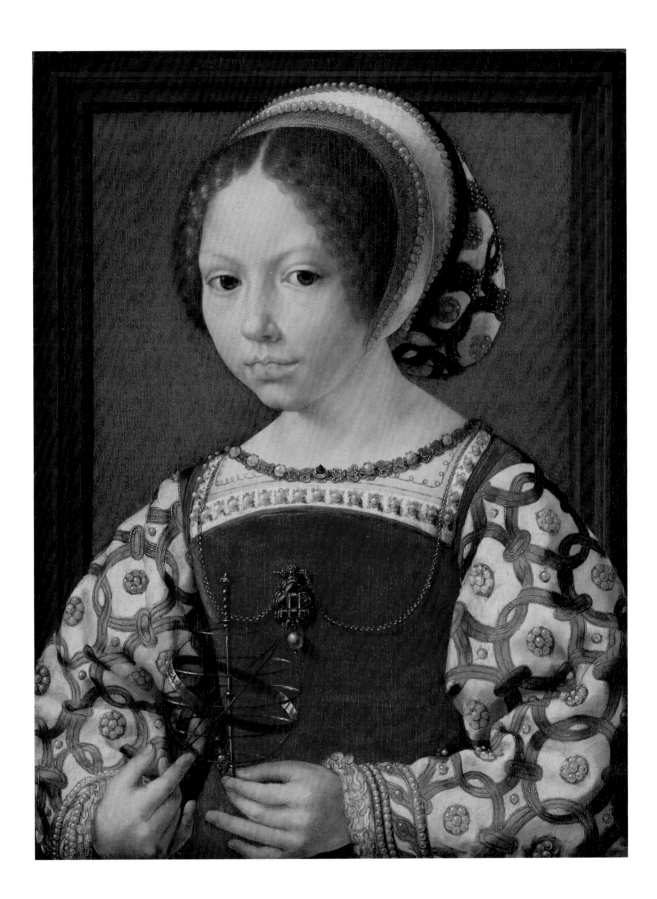

JAN GOSSAERT (ACTIVE 1503; DIED 1532)

Man with a Rosary

About 1525–30
Oil on oak, 68.6 × 48.9 cm
NG 656

Half-length devotional diptychs, in which the patron is portrayed on one of the interior wings, were a distinctly Netherlandish type. Rarely do both wings survive: this portrait of a man in prayer is the surviving right-hand wing of such an object.

In this example, Gossaert produces a highly convincing portrait, in which the broad play of light over the face and the tight detailing of the individual features are held in balance. The man seems to be lit partly by light emanating from the other wing, now lost, which probably depicted the Virgin and Child. A double-light window is reflected in each of his eyes. He has chosen to be depicted staring into the middle distance, holding a rosary and gently touching the area of his heart. Opening the diptych, he would see himself in this attitude of devotion and love, a device which presumably helped him to enter into the spirit of his private devotions. The colour scheme – composed of greys, blues and some warmer yellow-browns – is noticeably muted and restrained; brighter, more saturated colours probably appeared in the costume of the Virgin on the other wing.

The limited colour, broad lighting and astonishingly naturalistic likeness all combine to endow this portrait with a sense of volume and life. The subject's gestures appear more natural and expansive than in earlier such portraits (see, for example, Hans Memling's *Young Man at Prayer*, plate 18). The deep, glowing shadows and sharply delineated architecture, based on that of classical antiquity, place the figure in a highly convincing spatial environment.

40

JAN GOSSAERT (ACTIVE 1503; DIED 1532)

The Virgin and Child

1527
Oil on oak, 30.5 × 23.5 cm
NG 1888

Animated and muscular, the Christ Child assumes a dramatic pose. Balanced on one leg, he tilts his head back to look upwards, his arms widely extended in a gesture that foreshadows his future crucifixion. The Virgin restrains him, but gently, in such a way that the thumb and forefingers of her right hand span the area of his right breast, without encircling it; the gesture, which is not laboured but emerges subtly from the design, presumably alludes to Christ's role as a nurturer of mankind, who can feed us with his own body.

The inscription is based on Genesis 3: 15, and reads: 'Genesis 3: Jesus, the seed of the woman, has bruised the head of the serpent'. These words are based on God's address to the serpent after the Fall of Man, which warns that the Virgin's seed – that is, Christ – shall 'crush thy head, and thou shalt lie in wait for her heel'. Christ's role of vanquishing the devil can be inferred both from his pose in the painting (alluding to his sacrifice) as well as the direction of his glance (up towards the word 'SERPENTIS' in the inscription).

The convex letters of the inscription appear to have been crafted from gilt bronze and fixed within a concave stone cavity, an effect that would have been challenging to paint and was surely intended to advertise the painter's technical virtuosity. Another focus for admiration is the overall spatial arrangement, in which the Virgin and Child are depicted as if seated in front of the arched mouldings in the background, and come forward into our space, as does the entire foreground area, including the Virgin's footstool. Much admired in the sixteenth and subsequent centuries, the painting was repeated in numerous exact copies as well as a fine engraving dated 1589 by Crispijn de Passe the Elder.

JAN GOSSAERT (ACTIVE 1503; DIED 1532)

Adam and Eve

About 1520
Oil on wood, 168.9 × 111.4 cm
L 14
On loan from Her Majesty the Queen

Behind her back, Eve holds the apple. That Adam has eaten from it is indicated by his open mouth, visible teeth and wondering expression, and by the way he touches the tip of his finger to his mouth. His disequilibrium is expressed by the diagonal slant of his body away from Eve and by the way his feet are not firmly planted on the ground. The torsion in his pose is echoed by the twisted forms of the tree behind him, presumably the Tree of Life. His sexual awakening is further shown by the movement of the fingers of his left hand, which tentatively feel Eve's flesh, as if for the first time. This treatment of the subject is emphatically erotic.

Gossaert derived parts of these nude forms from engravings by Albrecht Dürer and Marcantonio Raimondi, the latter a collaborator of Raphael in Rome. These artists were, to a greater or lesser degree, interested in classical balance and ideal beauty, but Gossaert seems to have been more fascinated by the linear patterns and the twisting, interlocking forms that could be created from the nude figure. To bring these complex patterns and forms into focus, he often brought the edges and contours of the figures into sharp definition, shown most clearly here by the treatment of the entire left side of Adam's body, which can be read as a single, clear line. As shown by the treatment of the snake and of Eve's hair, Gossaert was also interested by the sophisticated linear patterns which may be produced by the play of elongated three-dimensional forms, turning and winding in space.

Gossaert also made small-scale versions of this subject, suitable for display in the picture cabinets of art collectors. This picture eventually came into the collection of King Charles I, to whom the Dutch States-General gave the picture in 1636.

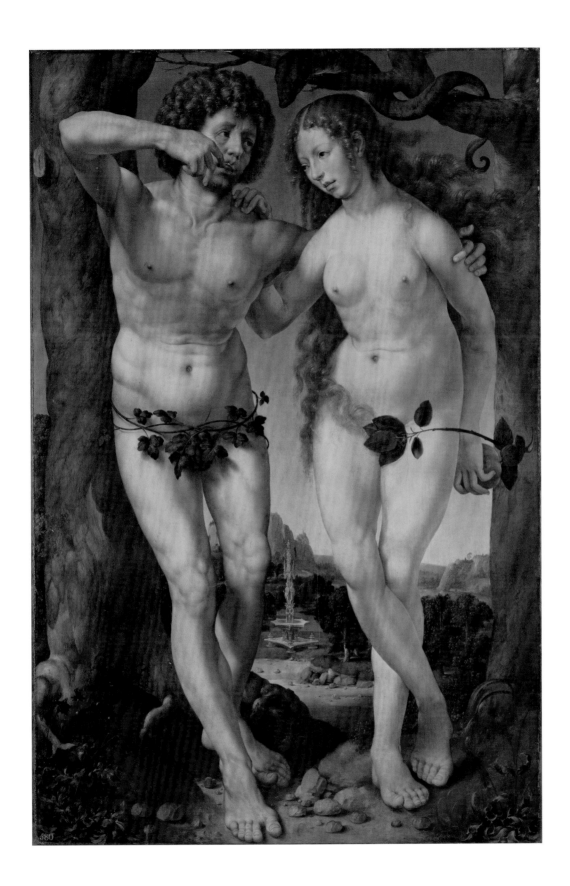

LUCAS VAN LEYDEN (ACTIVE 1508; DIED 1533)

A Man aged 38

About 1521
Oil on oak, 47.6 × 40.6 cm
NG 3604

The bust-length figure produces a crisp silhouette against the mid-green background. The man holds a piece of paper, inscribed with the number '38', but there are no other distractions from his face, which, though turned in space, is almost fully visible. The introduction of a deep shadow to a plain background, often in green or blue, is characteristic of sixteenth-century portraiture.

The double-light window reflected in each of the man's eyes indicates that he sat for Lucas looking directly into daylight; so minutely are these reflections recorded that it is possible to see shapes outside, through the window. Lucas seems to have chosen a position and a time of day which would provide bright lighting, and this had various consequences. One was that he could observe and record the finest gradations of tone and colour in the man's face with remarkable accuracy, another that the contrasting play of light and dark over the head was relatively great, allowing it to emerge as a three-dimensional form.

All the distinctive features of the man's face – including the low-set eyebrows and the direction of growth in the eyebrow hair – are carefully observed. We sense, however, that the portrait is not entirely objective: the eyes may be rather enlarged and the angles of the face may have been adjusted. Aesthetic concerns, as well as the sitter's desire for a flattering result, required the painter to modify the portrait while preserving a good likeness – a delicate balancing act.

The entire image suggests the care and concentration that went into making it – a characteristic of Lucas's work. A famed copper-plate engraver as well as a painter, he devoted much time to a medium that demanded intense craftsmanship and diligence. Lucas rose to prominence in Leiden during the 1510s, and became one of the most renowned artists of sixteenth-century Netherlands.

43

JOOS VAN CLEVE (ACTIVE ABOUT 1511; DIED 1540/1)

The Holy Family

About 1515–20
Oil on oak, 50.2 × 36.5 cm
NG 2603

The tight cropping of the scene presented in a shallow space produces a sense of intimacy between the figures. Joseph occupies a subsidiary role in the family relationship, however, shown both by his psychological remove – he reads and does not engage with the other two – and his visual separateness. While Mary is idealised, moreover, Joseph is more earthly and familiar. He is rendered with the features of a mature but not elderly man: grey hair, glasses for reading, and a double chin.

Mary's act of nursing her son reinforces his humanity. The Virgin was believed to be an effective intercessor between mankind and Christ – a mother who could encourage her son to forgive us for our sins. This role can be inferred from the intimate relationship between the Virgin and the Child, strengthened by the rosary within which she contains the infant.

Some of the items on the foreground ledge have symbolic meaning: cherries are symbols of paradise and the lilies are a reference to the Virgin's purity. The cut citron, with its bitter taste, may refer to the weaning of the child.

Van Cleve ran a successful workshop in Antwerp which produced versions of this subject in large numbers, all with similar interchanged elements. In other examples the Christ Child is depicted seated on the Virgin's knee; this is how he was originally shown in this painting, before being altered to the present standing position. The master and his assistants could probably choose features, whether the vase of lilies or the standing Child, from among several depictions of the Holy Family used as models in the workshop, making their working procedure both flexible and economical. The production of multiple variants of a single subject was typical of the tendency towards specialisation in early sixteenth-century Antwerp. The paintings were presumably made to be sold on the open market.

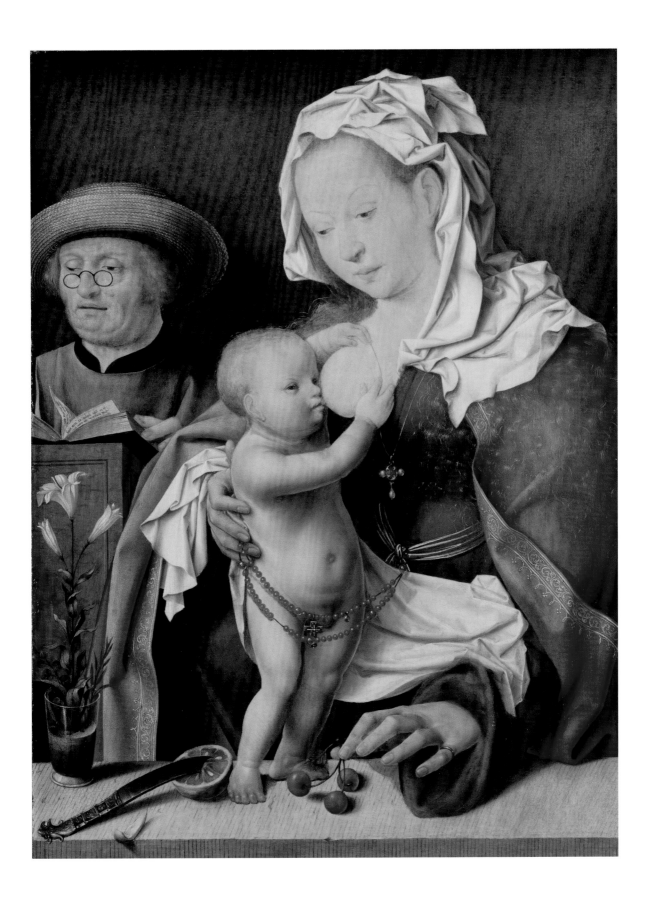

44

ADRIAEN YSENBRANDT (ACTIVE 1510; DIED 1551)

The Magdalen in a Landscape

Perhaps about 1510–25
Oil on oak, 40 × 31.1 cm
NG 2585

According to legend, Mary Magdalene spent the end of her life in solitary prayer and meditation at La Ste-Baume in Provence. She is shown not only in the foreground here, but also in the background, reclining with a devotional book at the entrance to the cave in which she lived. The borders of the pages in her book of hours are decorated with *trompe l'œil* flowers, a style typical of so-called 'Ghent-Bruges' manuscript illumination, beginning in the 1470s. The painting presents the Magdalen as a model of individual penitence and prayer – and of uninterrupted devotion. Small-scale paintings such as this could be placed on altars or in the home and used for private prayer.

The painting is materially beautiful and technically refined. The glowing red colour of the saint's mantle, with its deep, luminous shadows, stands out against the strong greens and green-blues of the landscape: that the painting retains so much of its original chromatic intensity is testament to its quality. The painter demonstrates his ability to portray convincing effects of near-transparency, most obviously in the saint's dress but also in the veil of her cap, through which we can just make out an image of a man on horseback. The sheer fabric of the dress serves only to emphasise the Magdalen's body, thus hinting at her early life of sin.

There are no signed or authenticated pictures by Adriaen Ysenbrandt, who registered as a free master in the Bruges guild of painters in 1510. Nonetheless, a large group of paintings has been attributed to him on the grounds that they broadly fit seventeenth-century descriptions that define him both as a 'disciple' of Gerard David and as a painter skilled in painting nudes and portraits. That the painter of this picture was well aware of David's work is shown by the Magdalen's face, which, while simplified, recalls David's types.

45

ATTRIBUTED TO THE WORKSHOP OF JOACHIM PATINIR (ACTIVE 1515; DIED NO LATER THAN 1524)

Saint Jerome in a Rocky Landscape

Probably 1515–24
Oil on oak, 36.2 × 34.3 cm
NG 4826

Depicted on a small scale in the foreground of a vast, rocky landscape, Saint Jerome (342–420) sits and holds the paw of his faithful lion, which became his close companion. This intimate scene takes place within a world that is otherwise cold, craggy and virtually unpopulated. If we compare this picture to other versions of the composition by Patinir, however, it appears likely that the picture has been cut down considerably on the right-hand side, which would have shown fields and low, rolling hills as well as open water (see fig. 18, p. 30). In its original condition the painting probably represented a threefold distinction between the saint's retreat in the foreground, a remote wilderness landscape on the left, both shown here, and a gentle, more cultivated landscape on the right. While the precise significance of these contrasts has been debated, the various terrains perhaps correspond to different arenas of human behaviour and activity, among which the saint's retreat is the least hospitable but the most spiritual place.

The invention of this type of landscape, seen from far above, is associated with Joachim Patinir, who enrolled as a master in the Antwerp guild of painters in 1515. His landscapes are fantastic rather than observed from nature and, though the textures of the various stones are highly convincing, they resemble rocks observed on a small scale and made to play the role of mountains.

The landscapes provide various pockets of space in which narrative episodes are played out simultaneously. Another episode in Saint Jerome's legend takes place on the mid-ground plateau here: the lion fell asleep while guarding an ass belonging to a monastery, allowing it to be stolen by a party of passing merchants. Recognising the thieves on their return to the area, the lion made up for this lapse; here, they have fallen to their knees to beg forgiveness from the abbot.

MASTER OF THE MANSI MAGDALEN

Judith and the Infant Hercules

Probably about 1525–30
Oil on oak, 89.5 × 52.7 cm
NG 4891

The nude figures are depicted against a dark background, given a sense of three dimensions mainly by the fact that their feet are foreshortened, receding in space as though they tread on the ground.

Judith, shown with a sword, displays the head of Holofernes, an Assyrian general whom she decapitated when, overcome by drink, he lost consciousness. By this act of heroism she plunged the Assyrian army, then besieging the Jewish city of Bethulia, into disarray, gaining an important victory for her people. Hercules, a hero of ancient mythology, holds in each hand a snake decked with a peacock crown, representing his deed of strangling two snakes sent by the goddess Juno (whose emblem was the peacock) to kill him and his brother in their cradle.

The figures are shown here as twin personifications of Fortitude, one of the four Cardinal Virtues, which encompassed strength, courage and endurance. Judith's body is strongly muscular, physical and three-dimensional, intended less to titillate the viewer than to underscore the heroism and strength of her actions. The poses, gestures and even the physiques of Judith and Hercules reflect and echo each other, suggesting that their nudity can be interpreted in the same way, as the outward sign of fortitude, the common characteristic that binds them together. It has been proposed that Judith's gender is also relevant to the picture's interpretation. By showing a woman as an exemplar, the painter would be conveying an idea then current that an exemplary deed is all the more effective when performed by a weak individual, such as a woman – or, as suggested here, by an infant.

This picture exemplifies the prestige of the classically inspired nude during the 1520s, and the existence of a demand for complex allegory among sophisticated buyers. The painter, whose identity is unknown, was an Antwerp follower of Quinten Massys.

47

WORKSHOP OF MASTER OF THE FEMALE HALF-LENGTHS

The Rest on the Flight into Egypt

About 1525–50
Oil on oak, 81.9 × 62.2 cm
NG 720

Warned by an angel in a dream that King Herod of Judea sought to have the infant Christ killed, Joseph took Mary and Jesus to Egypt for safety. Early sixteenth-century depictions of the rest on the journey tend to set the scene within a landscape, with the holy family eating or gathering fruit from a tree. In this picture Joseph is offering the fruit from his position behind the family group, giving the painter an excuse to show the nude Christ Child twisting round in space. His classical pose and musculature, and those of the bronze statue of Cupid on the right, are fashionable references to antique art.

In the background is the embellishing episode of the Miracle of the Corn, in which the pursuit of the family is halted by the evidence of a farmer planting seeds, who assures the soldiers that the holy family had passed by when the crop – now miraculously grown – had just been sown. While this anecdotal detail may have furthered the viewer's empathy with the holy figures, heightening his reverence for them, the landscape is primarily of interest for its beauty, harmony and clarity. It reveals the artist's skill in spatial organisation – as the nearby architecture gives way to ever-smaller structures – and at evoking space through colour as the landscape, unfolding towards the horizon, changes from green to a range of subtly related blues.

The Master of the Female Half-Lengths, active in the 1520s and 1530s, is named after a type of imagery in which he and his associates specialised: courtly ladies reading, writing and playing musical instruments. Like *The Rest on the Flight into Egypt*, these pictures offer a deliberate variety of figures, landscape and classical references, as well as showcasing refined techniques such as the smooth blending of the flesh tones of the female figures.

48

MARINUS VAN REYMERSWAELE (ACTIVE 1535–1545)

Two Tax Gatherers

About 1540
Oil on oak, 92.1 × 74.3 cm
NG 944

Satirical images with a moral message, like this one, were enormously popular in the sixteenth century. While the face of the man on the left appears rather ordinary and unremarkable, that of the man on the right, who claws at the air like an animal, is a grotesque, distorted mask. That both are implicated in the satire is shown by their common outlandish dress. The pink horned headdress of the man on the left is ludicrously large and, furthermore, designed for a woman. Both headdresses have over-abundant dagging (slashed edges) of a type that was thoroughly outdated by this date, no doubt also intended to make them look foolish.

At this period, taxes on various comestibles such as fish, wine and beer were farmed out by the municipal authorities to be collected by private individuals. The revenues from such taxes are being recorded here, with legible precision, in a large account book. This, along with the substantial pile of coins on the table, indicates that the men are being attacked specifically for their greed and avarice. Various subjects of sixteenth-century painting aimed to expose the greed of the merchants, bankers and financiers of Antwerp and other Netherlandish cities (though such moralising images had already appeared in the fifteenth century). Scores of versions of this particular image survive, of varying quality, some of them by followers of van Reymerswaele, indicating that its success was both wide and enduring. The market for such images is uncertain. The buyers may even have included people active in commerce, who may have wished to reflect on the business in which they were engaged.

If van Reymerswaele's subject matter and moralising concerns are rooted in painting in early sixteenth-century Antwerp, he does not appear to have settled there; it is possible that he was active mainly in Zeeland (Reymerswaele, after which he was named, was a town in Zeeland).

49

CATHARINA VAN HEMESSEN (1527/8 – AFTER 1566?)

Portrait of a Lady

1551
Oil on oak, 22.9 × 17.8 cm
NG 4732

So small is this portrait that it can easily be carried in the hand and observed from close-to. With soft strokes of the brush, van Hemessen captures all the particularities of the woman's face – her small chin and the bags under her eyes – producing a portrait that is sensitively observed and direct. A variety of brushmarks is used to distinguish the textures of the various black materials, the soft velvet undersleeves and the long hair of the dog, the latter captured with fluid strokes. In minute detail van Hemessen tightly defines the black edging of the ruffs at the neck and wrists, the tiny baubles (or bells) hanging from the dog's collar, and the orange and black embroidery of the glove in the woman's hand. A single glove, especially if beautifully embroidered like this, was a fashionable accessory and here indicates the lady's status (see p. 108). In this portrait, however, the display of status is much softened by the inclusion of the little dog, which has personal rather than symbolic meaning. Overall, the portrait seems to strike a balance between formality and display, on one hand, and delicacy and naturalness on the other. The modulation of the neutral background creates an impression of spaciousness which accords with the sense of mobility in the figure.

The picture is one of a body of such small-scale portraits by the artist, dating from the late 1540s and early 1550s, most of which show women. Van Hemessen was well educated and from an artistic family: her father was a painter, as were her two brothers; her sister Christina probably practised music. Her husband (whom she married in 1553) was the virtuoso organist Chrétien de Morien, employed, among other places, at the court chapel of Mary of Hungary. Van Hemessen's portraits seem to reflect this cultivated world – particularly in that many of them show her name, inscribed in Latin.

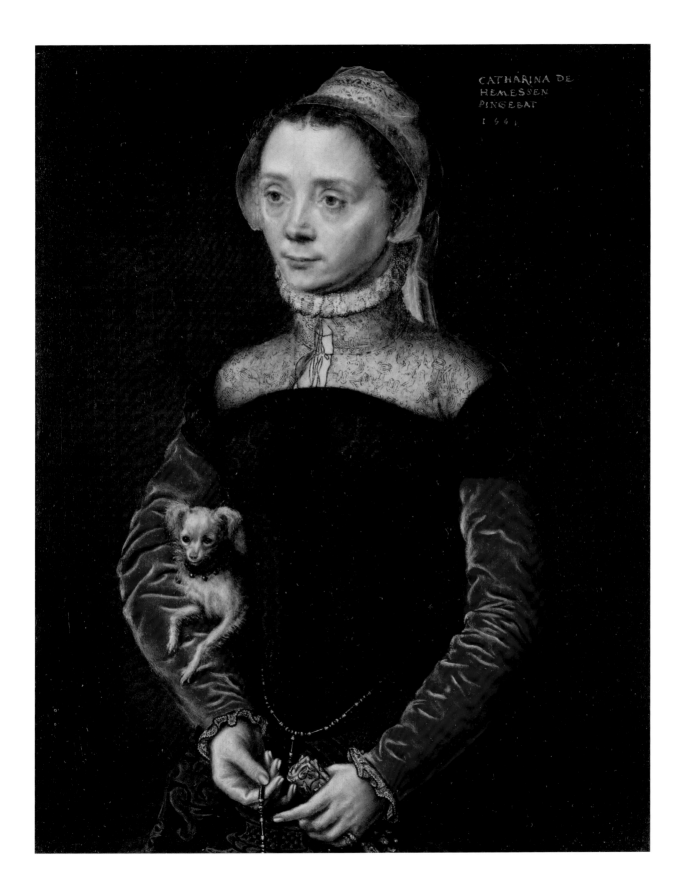

CATHARINA DE
HEMESSEN
PINGEBAT
1 5 5 1

50

PIETER BRUEGEL THE ELDER
(ACTIVE 1550/1; DIED 1569)

The Adoration of the Kings

1564
Oil on oak, 111.1 × 83.2 cm
NG 3556

In conventional representations of this subject the kings usually form a procession of opulent grandeur (compare Jan Gossaert's version, plate 34). Bruegel instead creates an uneasy scene in which some of the characters appear tired and unfocused (even Joseph is distracted by someone whispering into his ear). The soldiers with halberds and a crossbow seem incongruous in their close proximity to the mother presenting her child.

The theme of seeing permeates the picture, in which the round, staring eyes of the onlookers in the upper left attract our attention and a figure on the far right wears glasses with thick lenses. This emphasises his act of looking, but can also be interpreted as a metaphor for his inability to see Christ's divinity. It is unclear what, if anything, the partial veiling of the Virgin's face denotes. Christ seems to recoil from the kneeling figure of the eldest king, Caspar, who probably offers him myrrh, used to anoint the dead, here foreshadowing Christ's Passion. The child's gesture may signify his reluctance to accept his fate. Bruegel's unusual representation of the subject may indicate that the picture was intended for private viewing rather than for the more formal, public setting of a church altar.

Not only in its interest in themes of seeing but also in its technique, *The Adoration of the Kings* lies firmly within the Netherlandish tradition. Bruegel's manipulation of thin layers of paint, leaving the brushstrokes visible, finds analogies in the work of Hieronymus Bosch. Moreover, his use of a wooden point, perhaps the end of his brush, to scratch or scrape away at the topmost layer of paint, thus exposing the layer below (see fig. 5, p. 10), goes back at least to Jan van Eyck. These techniques, carried out rapidly but with astonishing control, indicate that speed of execution was prized in Netherlandish oil painting.

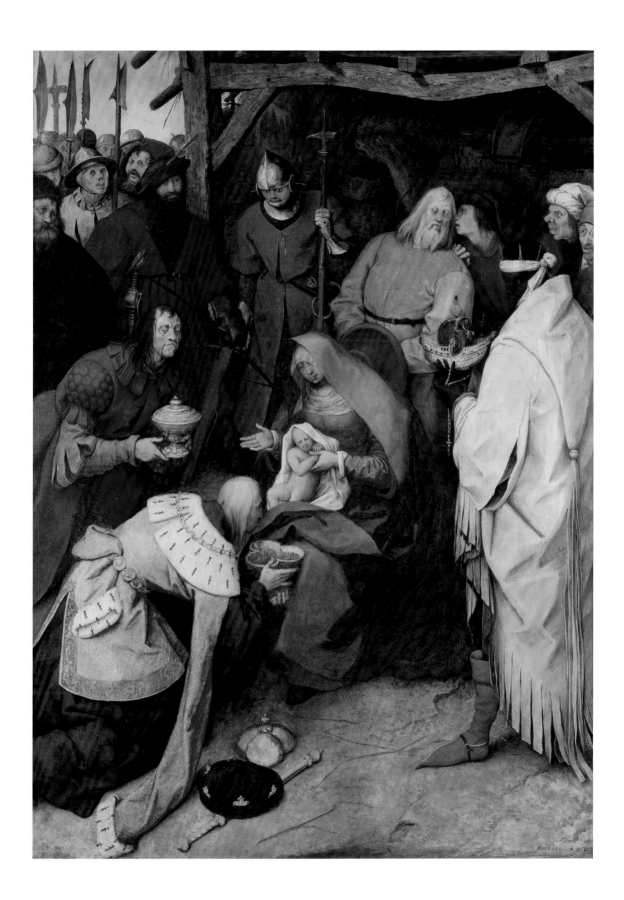

51-4

JOACHIM BEUCKELAER (ACTIVE 1560–1574)

The Four Elements

1569–70
Oil on canvas, *Earth* (plate 51) 157.3 × 214.2 cm, *Water* (plate 52) 158.5 × 215 cm,
Air (plate 53) 157.7 × 215.5 cm, *Fire* (plate 54) 157.5 × 215.5 cm
NG 6585, 6586, 6587 and 6588

Each of the pictures in this set of four features a sumptuous display of food related to the elements – fruit and vegetables with earth, fish with water, fowl with air and meat with fire. Each also contains a biblical scene in the background, which relates to a greater or lesser degree to the main subject in the foreground.

The paintings are all scenes of healthy abundance of products of the earth. Painted at a period of harsh economic recession and meagre harvests, they may hark back nostalgically to the robust economy of mid-sixteenth-century Antwerp. Beuckelaer has represented the various comestibles with great care, allowing for the identification of a number of species of fish, fruit and vegetables. The episodes from the Bible add another dimension, though their interpretations are not agreed upon. It is possible that the wealth of choice and quality of the foodstuffs was meant to encourage the consumer to contemplate his or her own spiritual sustenance. *Fire*, for example, features a meal prepared in a kitchen, while in an adjacent room Christ is shown with Martha and Mary. In the story, when Martha complains to Christ that instead of listening to him Mary should help prepare the meal, Christ admonishes Martha that Mary has made the right choice. While this clearly offers a moralising lesson, the representations of Christ's miraculous production of fish in the empty nets of his disciples (*Water*) and the Flight into Egypt (*Earth*) do not lend themselves to such obvious explanations. *Air* contains an episode from the story of the Prodigal Son.

Market scenes were a new genre in painting of mid-sixteenth-century Antwerp, and Joachim Beuckelaer, a native of the town, was one of its two main practitioners. These market scenes extended their influence to the seventeenth-century Dutch Republic and to Northern Italy, where they inspired painters such as Annibale Carracci (1560–1609).

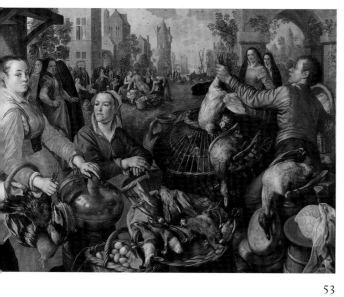

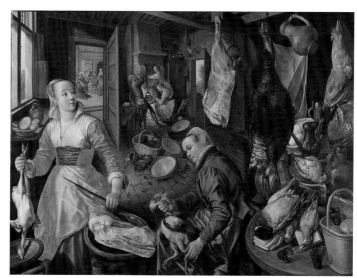

LIST OF PLATES

GLOSSARY

diptych A work consisting of two parts, normally hinged like a book. Many Netherlandish diptychs are painted in oil on wood panels.

egg tempera A paint *medium* in which pigments are mixed in egg yolk.

glaze A layer of translucent paint applied over other paint to modify its colour, or to give depth and richness of colour. Glazes are often formed by combining pigments with an oil *medium*.

glue-size Made by boiling animal skins and other tissues, glue-size can be used as a paint *medium*.

grisaille From the French *gris* (grey), grisaille refers to a work made in different shades of a single colour, usually grey or brown; it was sometimes used to simulate relief carving or sculpture in the round.

ground The preparatory layer or layers laid on to a panel or canvas to prepare the *support* for painting. In Netherlandish panel painting, the ground is usually chalk (calcium carbonate).

medium The binding agent for pigments in a painting; see also *oil, egg tempera, glue-size*.

oil The oils used in oil paint are drying oils – that is, oils which dry naturally in air – such as linseed, walnut and poppyseed oil. Pigments are first ground, then dispersed in this oil *medium*, to make paint.

panel A rigid painting *support*, usually made from planks of wood.

polyptych A work, often painted or carved, that consists of many parts. The polyptych format was often chosen for altarpieces.

support The material on which a painting is made, often wood panel or canvas, but also copper, stone or any other material so used.

triptych Consisting of three parts, Netherlandish triptychs sometimes had folding wings that closed over the central section. Triptychs often functioned as altarpieces but were also used for private devotion.

underdrawing A drawing made on the prepared *support* before the application of paint; in Netherlandish painting it was often made in brush in an aqueous *medium*. The underdrawing served as a compositional guide for the painter. Underdrawing can sometimes be detected by means of infrared reflectography, an imaging technique which uses infrared radiation to 'see through' paint layers that are opaque to the human eye.

ACKNOWLEDGEMENTS

This book is in many ways a tribute to the remarkable scholarship of Lorne Campbell, whose 1998 catalogue of the fifteenth-century Netherlandish paintings in the National Gallery was the essential source for this brief overview of the subject. Having benefited from Lorne's help and encouragement over many years, I would like to express my thanks to him here, as well as to acknowledge and thank: Gill and Ted Alderman, Susan Foister, Jill Dunkerton, Rachel Billinge, Catherine Reynolds, Ariane Mensger, Susie Nash, Paula Nuttall, Greg Perry and Larry Silver.

FURTHER READING

L. Campbell, *The Fifteenth Century Netherlandish Schools. National Gallery Catalogues*, London 1998

J. Dunkerton, S. Foister, D. Gordon and N. Penny, *Giotto to Dürer: Early Renaissance Painting in The National Gallery*, New Haven and London 1991

J. Dunkerton, S. Foister and N. Penny, *Dürer to Veronese: Sixteenth-Century Painting in The National Gallery*, New Haven and London 1999

E. Langmuir, *A Closer Look: Allegory*, London 2010

S. Nash, *Northern Renaissance Art*, Oxford 2008

National Gallery Technical Bulletin, eds L. Campbell, S. Foister and A. Roy, vol. 18, London 1997

P. Nuttall, *From Flanders to Florence: The Impact of Netherlandish Painting, 1400–1500*, New Haven and London 2004

PHOTOGRAPHIC CREDITS